D1645285

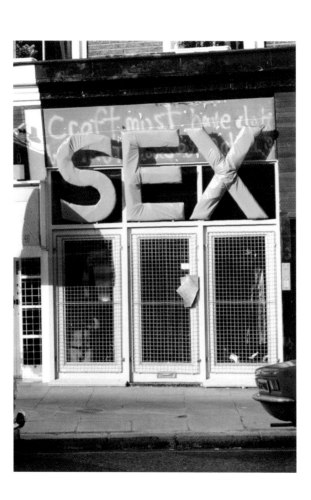

A CHEQUERED PAST

my visual diary of the 60s and 70s

Peter Schlesinger

Foreword by Manolo Blahnik

For Alfred "Bud" Schlesinger

First published in the United Kingdom in 2004 by
Thames & Hudson Ltd, 181A High Holborn, London WC1V 7QX

www.thameshudson.com

Copyright © 2003 The Vendome Press
All photographs and text copyright © 2003 Peter Schlesinger,
unless otherwise noted
Foreword copyright © 2003 Manolo Blahnik

Printed and bound in Singapore

British Library Cataloguing-in-Publication Data
A catalogue record for this book is available from the British Library

ISBN 0-500-54283-X

ON THE COVER: La Piscine Deligny, Paris, 1975.
PAGE 1: Vivienne Westwood's shop, London, 1975.
TITLE PAGE: Peter Schlesinger, Paris, 1969. Photo by David Hockney.
ABOVE: Self-portrait, West Sussex, 1977.
OPPOSITE LEFT: Wayne Sleep, Barcelona, 1971.
OPPOSITE RIGHT: Eric Boman and Bianca Jagger, New York, 1974.

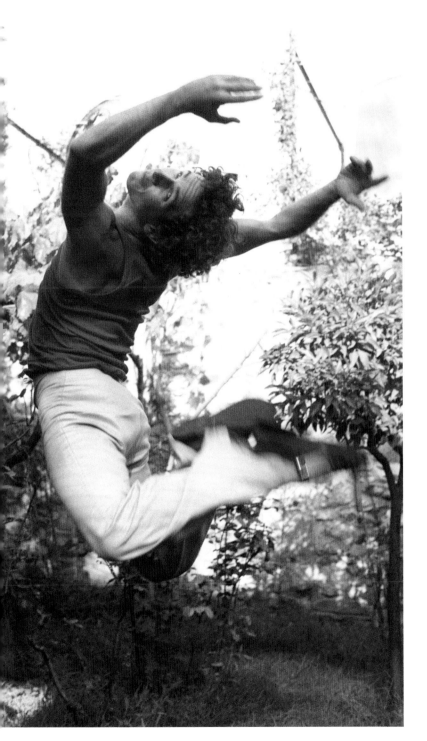

CONTENTS

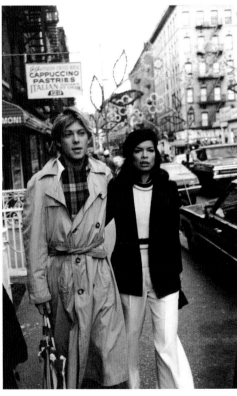

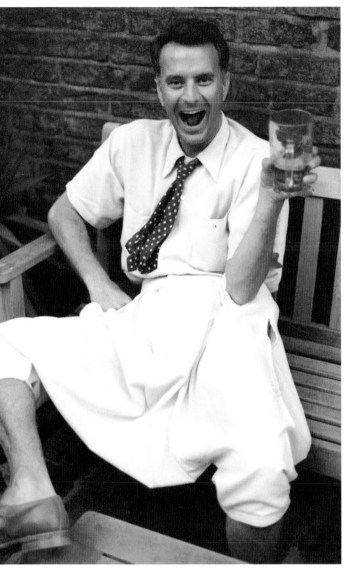

MANOLO BLAHNIK, LONDON, 1977

NONSTOP WITH A

companions. But most satisfying are the films and photographs by people I admire, because they have the power to surprise and delight. It has frustrated me over the years that I have been unable to create either myself, something I have seriously considered. We do what we can, and I make shoes.

Imagine my delight at meeting Peter Schlesinger, who was making beautiful paintings, but also working nonstop with his camera. Soon after becoming friends, I moved to a flat in the same house where he lived, and from that day I closely followed the way he recorded our lives. Peter had a different attitude and a fresh vision—maybe because he was an American—and I had never seen anyone with that kind of sensitivity before.

We were in our twenties, and every time I met someone new, life seemed to take a slightly different course. I started seeing a lot of Peter and, of course, Eric, whom I had known for several years already, and we soon became very close friends. In fact, these incredible years in London are impossible to

Pictures are incredibly important to me. I see now that I have lived my whole life vicariously through images, both still and moving. The reality of life can often seem rather sordid to me, and I have preferred to live in an imaginary world made up of images that somehow make it more interesting, more perfect. Some of these are of my own invention, like recurring fantasies that have become traveling

CAMERA

separate from my relationship with them. The three of us fitted perfectly: we were all foreigners with different backgrounds. Truly exuberant and expressive people, we somehow managed to make an event out of nothing, laughing all the time.

Since Peter and I were neighbors, I'd often get to see his photographs even before they were glued into the albums, and they provided a sort of instant enhancement to the reality they portrayed. Nothing opened my eyes like Peter's pictures, and I could go on for days about them. But now I don't need to, and I feel very lucky to have this evocative book to remind me of a wonderful time in my life.

MANOLO BLAHNIK
2003

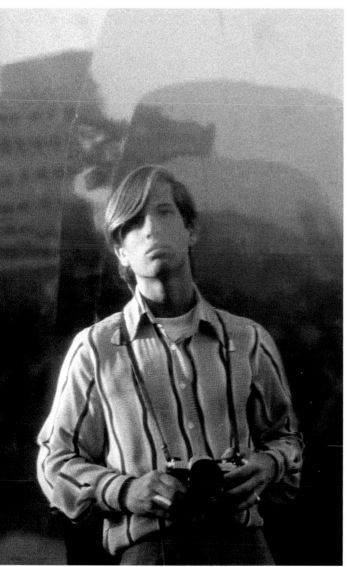

SELF-PORTRAIT, LOS ANGELES, 1968.

introduction
FROM KANSAS TO

My father had always been interested in photography, and to encourage me he asked his sister, who was a lieutenant commander in the U.S. Navy, to bring me a Pentax back from Japan in early 1968. My first pictures were black-and-white, but I soon switched to color.

It quickly became a habit to take my camera wherever I went, and to use it as a sort of third eye to capture what went on around me. Inspired by Eugène Atget and Walker Evans, I became more seriously intrigued with the possibilities of photography by the time I moved to London. I wanted to record my new experience of the old city by photographing its architecture, shop fronts, and objects, as well as the people I met.

I arrived in London as a new generation had taken over. The idea of youth had twisted this traditional nation into a new, exciting shape. The stars of this new establishment could be musicians from the working class, designers from the middle class, and models from the

My first experiences using a camera were around 1962 when I fooled around with a Brownie on subjects like my friends dressed up as beatniks and, later, the World's Fair in New York. A photography course at summer camp confirmed my interest: I liked seeing my surroundings through the lens, and I longed to have a proper camera of my own.

OZ

SHOP, SANTA MONICA, 1968.

aristocracy—it was a radically different kind of democracy. But this revolution, as it was referred to at the time, had not thrown out the old as a matter of course. The days of the Empire were by then long gone, but not so the English romance with faraway places or its nostalgia for the past. The contrast of old and new added incredible dimension and richness—Victorian long coats mixed with silver mini dresses.

My technical approach to picture taking was pragmatic: I used amateur print film and took it to the corner pharmacy for processing. The only thing I was interested in was the content of the image, and to render it as lifelike as I could. Abhorring the look of flash, I learned to stand very still when light conditions demanded it. At Wallace Heaton on Bond Street, I found beautiful, large albums in which I carefully arranged my photographs.

As the albums multiplied over the next ten years, they became even more important to me. Intent on documenting life around me, I had ended up making a visual diary of my own life. The albums enabled me to take my experiences with me when I finally left London, along with a different outlook on life, some cherished English habits, and many solid friendships that remain unchanged.

PETER SCHLESINGER
2003

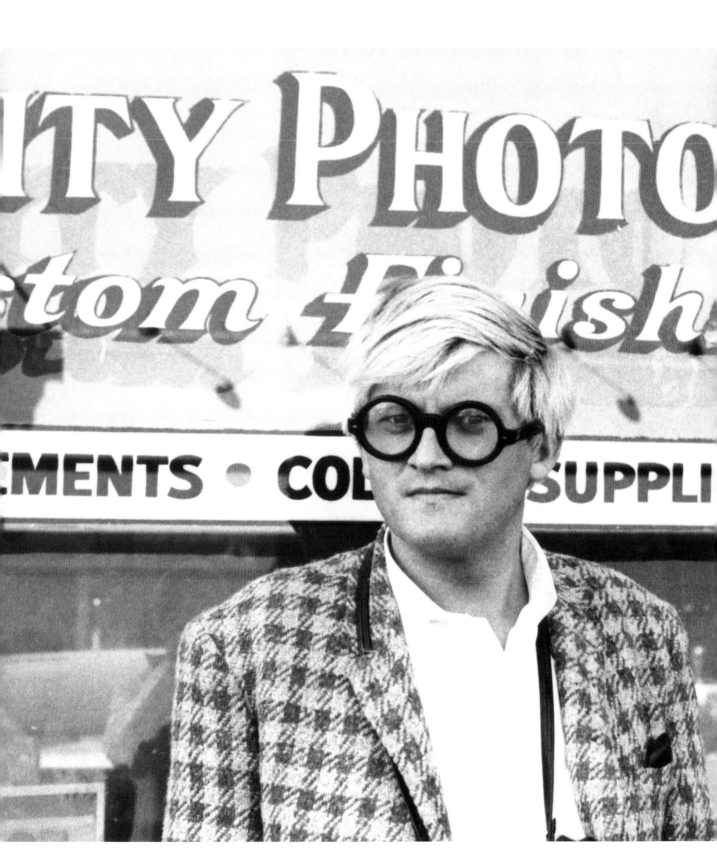

By the time I was about seven or eight, I knew I wanted to be an artist. On Saturdays during my high school years, my father would drive me all the way to UCLA so I could take art courses. In 1965 I entered the University of California at Santa Cruz, which was beautiful and fun in those early hippie days, but there were no art classes. So, in the summer of 1966, I came down from Santa Cruz to take a drawing course at UCLA. On the first day of class the professor walked in—he was a bleached blond; wearing a tomato-red suit, a green-and-white polka-dot tie with a matching hat, and round black cartoon glasses; and speaking with a Yorkshire accent. At the time, David Hockney was only beginning to become established in England, and I had never heard of him.

DAVID HOCKNEY, SANTA MONICA, 1968.

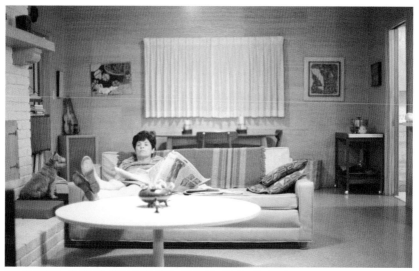

MY MOTHER, MARION SCHLESINGER, AND STRUDEL, ENCINO, 1968.

California's San Fernando Valley in the 1950s was a rather remote area before the freeways were built. Teasingly close, Hollywood was two hours away by bus, but old ranches and estates of movie people were mixed in with the encroaching suburban culture of which my family was a part and which triggered my imagination of a different life.

OPPOSITE: HOLLYWOOD BOULEVARD, 1968. ➤

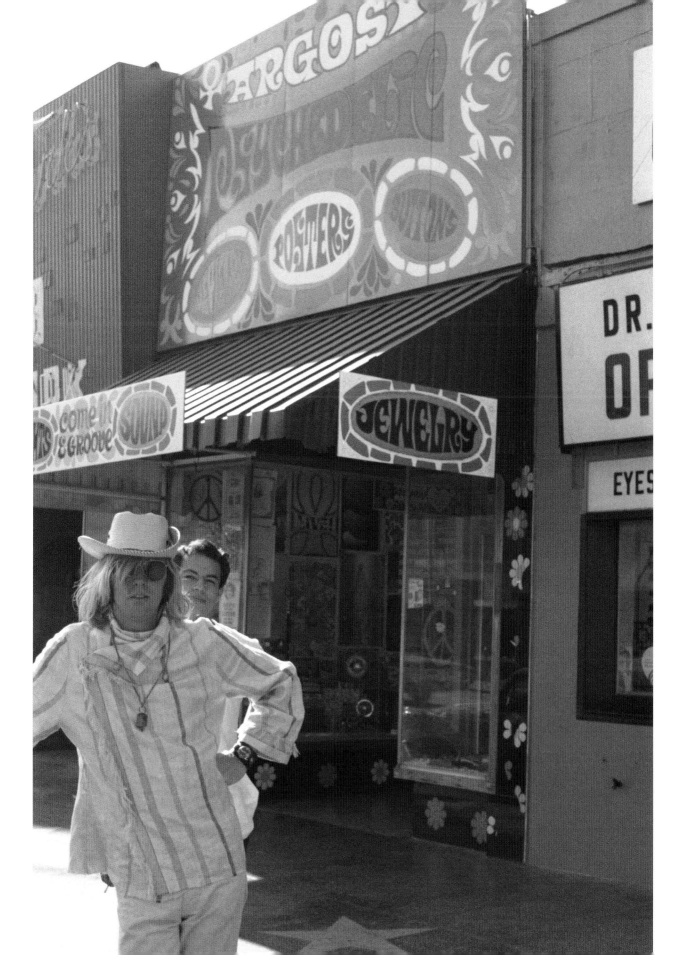

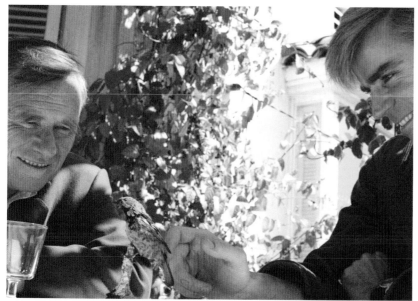

CHRISTOPHER ISHERWOOD AND DON BACHARDY, SANTA MONICA, 1968.

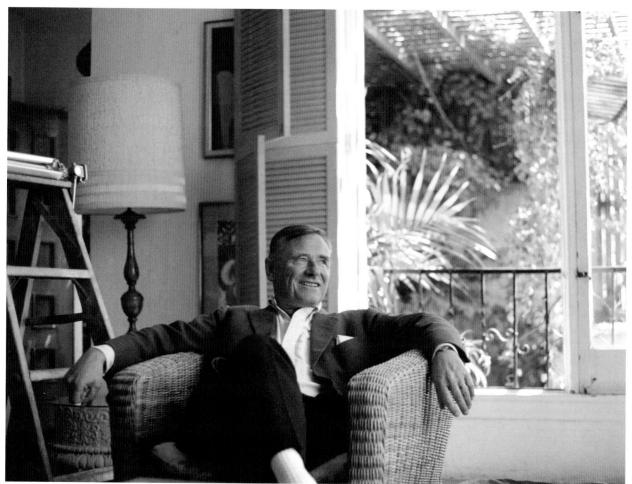

CHRISTOPHER ISHERWOOD, SANTA MONICA, 1968.

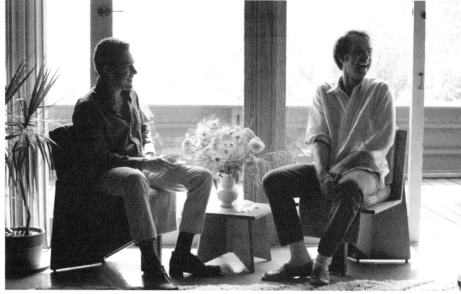

JACK LARSON AND JAMES BRIDGES, LOS ANGELES, 1968.

My horizon quickly expanded as I was introduced to David Hockney's large circle of friends. The poet Jack Larson, who wrote librettos for Virgil Thomson, had played Jimmy Olsen in the *Superman* TV series, and he lived with James Bridges, the movie director, in a diminutive Frank Lloyd Wright house in Los Angeles, which they had rescued from orange linoleum and a leaking roof. Christopher Isherwood and Don Bachardy were neighbors of ours who lived in an art-filled, old Spanish house overlooking the Pacific. Christopher wrote in a book-lined study, and Don drew his portraits of movie stars in the garage-turned-studio. The six of us spent many hilarious evenings together, often at a little Japanese restaurant where they would sneak me sake, illicitly, as I was only eighteen.

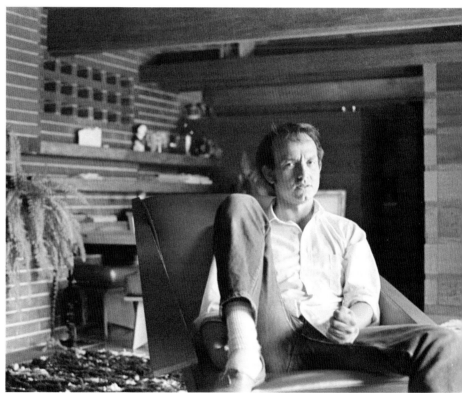

JAMES BRIDGES, LOS ANGELES, 1968.

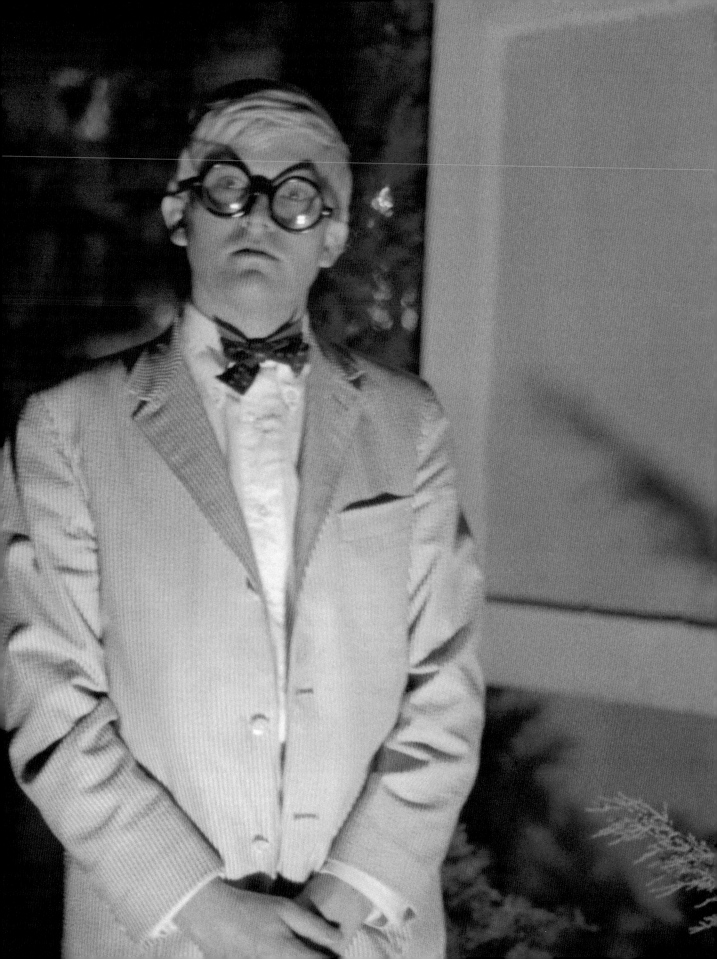

DAVID HOCKNEY, SANTA MONICA, 1968.

David Hockney's image and personality intrigued me. He represented a world outside my own that I was eager to embrace, and we were soon spending more and more time together, eventually becoming lovers. After another semester at Santa Cruz, I transferred to UCLA to take art full time and moved in with David in a run-down house in Santa Monica.

OPPOSITE: DAVID HOCKNEY, SANTA MONICA, 1968.

FRANCE, 1968.

The summer of 1967, David Hockney and I toured Europe. This further convinced me that I was born on the wrong continent in the wrong century, and I had to persuade David that we should move to London so I could study painting at the gloomy old Slade School of Art. We agreed to go the following year.

Leaving America forever by air seemed unromantic, so I sailed from New York on the *France* in September. Even before leaving the dock, I happened upon Jim and Nancy Dine, whom I had met before, and we took our meals together in the Palm Court. I arrived in Southampton with everything I owned in one large trunk to begin my new life in gray and sniffly London.

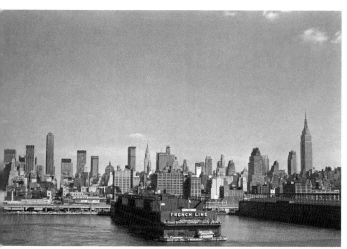

THE NEW YORK SKYLINE, 1968.

FRANCE, 1968.

ON BOARD THE FRANCE, 1968.

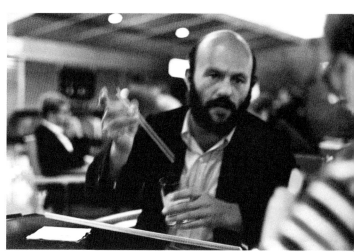

JIM DINE, 1968.

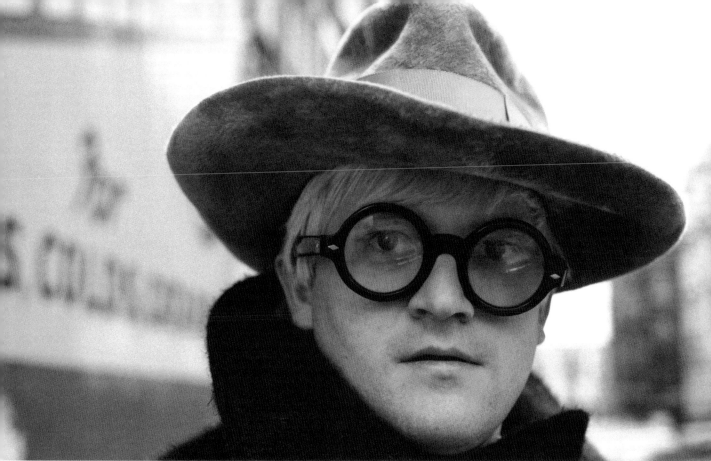

DAVID HOCKNEY, POWIS TERRACE, LONDON, 1968.

David Hockney had lived in his flat in Powis Terrace, in unfashionable Notting Hill, since he was a student. It was cheap and large, meandering through two houses. David's studio was a former bedroom and mine a room in his old friend Ann Upton's flat around the corner.

The streets were deserted of cars and looked quite depressed, but nearby was the bustling Portobello Road market, where I shopped for fruits and vegetables and old junk, which are now valuable antiques.

ME AS AN ART STUDENT, 1968.

OPPOSITE: DAVID HOCKNEY, POWIS TERRACE, LONDON, 1968. ➤

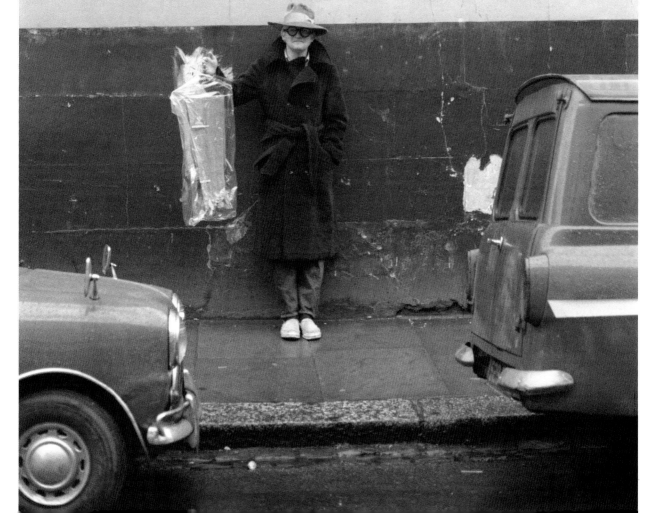

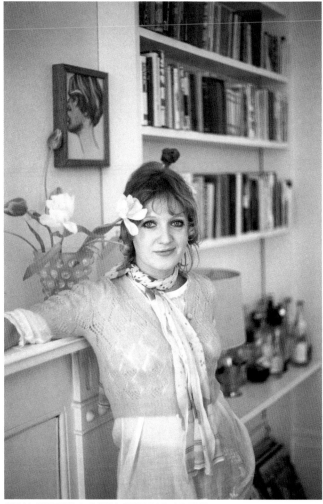

CELIA BIRTWELL, POWIS TERRACE, LONDON, 1968.

The textile designer Celia Birtwell was a close friend and a regular visitor to Powis Terrace. She designed printed textiles of great, almost innocent beauty, and she worked so closely with the fashion designer Ossie Clark that they married.

 OPPOSITE: DAVID HOCKNEY IN HIS STUDIO, POWIS TERRACE, LONDON, 1969. ➤

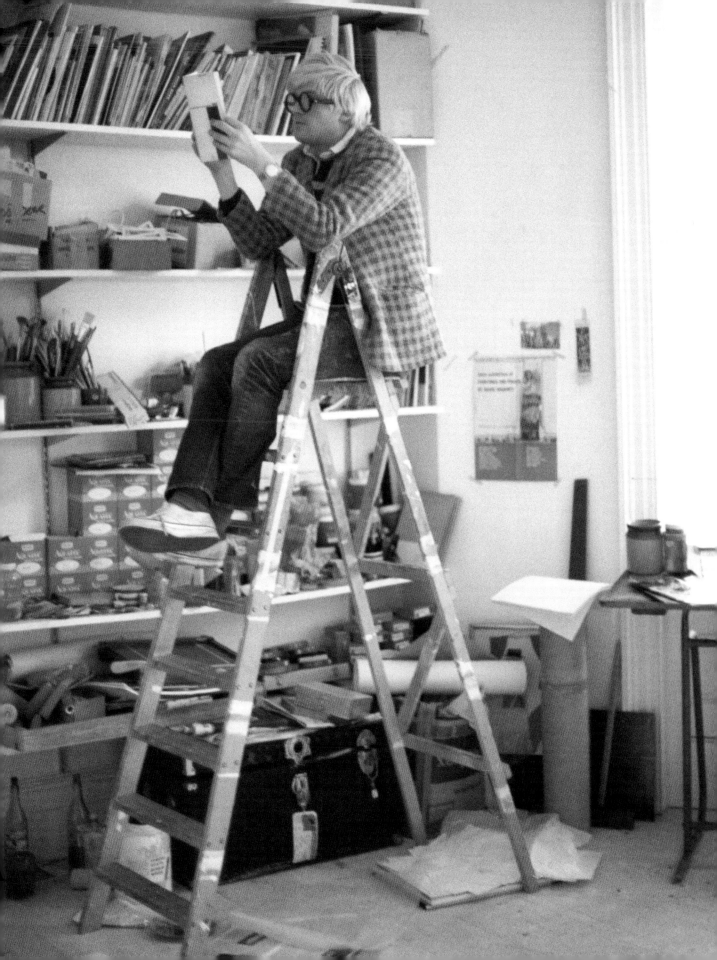

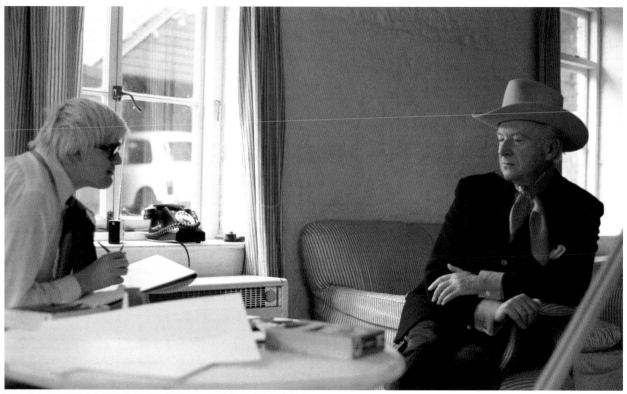

DAVID HOCKNEY DRAWING CECIL BEATON, REDDISH HOUSE, 1969.

SIR JOHN GIELGUD, POWIS TERRACE, LONDON, 1969.

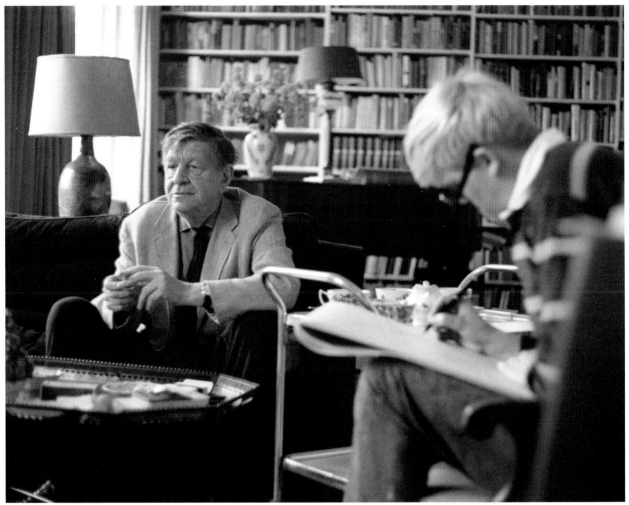

DAVID HOCKNEY DRAWING W. H. AUDEN, LONDON, 1969.

A constant stream of people came to the flat to pose for David Hockney, or just to have a cup of Fortnum & Mason tea. David didn't like to do commissions, but when asked to draw W. H. Auden, he couldn't resist, and he brought R. B. Kitaj and me along to draw, too. Feeling he'd been put on display, Auden was furious, so I tried to be as inconspicuous as possible. His lined face was a perfect subject for line drawing.

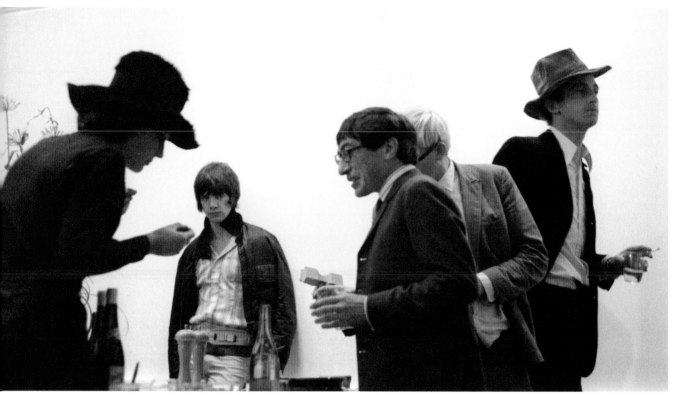

LINDY DUFFERIN, GERVAISE, KASMIN, DAVID HOCKNEY, AND PATRICK PROCTOR, KASMIN GALLERY, 1968.

The London art world of the late sixties was quite small. There was only a handful of galleries dealing in contemporary art, and everyone knew each other. The Kasmin Gallery, where David Hockney showed, was backed by Sheridan and Lindy Dufferin. It represented mainly American abstract artists and it had a very modern feel to it. The English were rather snooty about modernism, the reverse of the American art establishment, which considered figurative art old-fashioned.

DAVID HOCKNEY AND ART CRITIC GENE BARO, 1968.

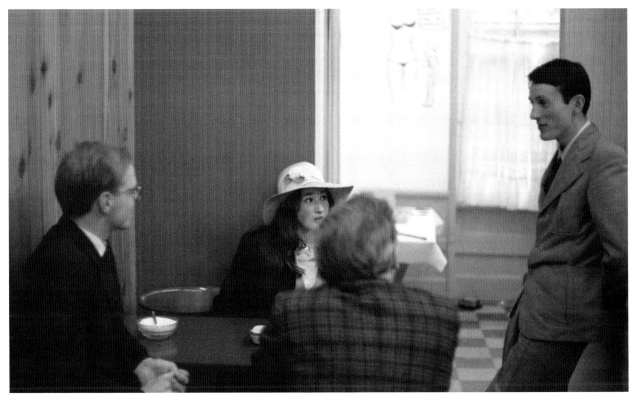

GILBERT AND GEORGE, 1970.

Gilbert and George would come for tea and not say much at all, appearing deliberately self-conscious. Everything about them was very controlled—their life was their art. They first became known performing the old pub standard "Underneath the Arches" under real railroad arches, miming to a tape. Nigel Greenwood brought them into his gallery on Glebe Place, and to fame.

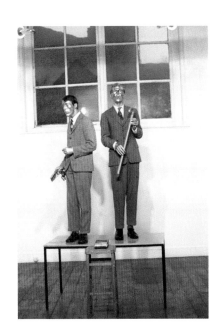

GILBERT AND GEORGE, NIGEL GREENWOOD GALLERY, 1970.

CELIA BIRTWELL IN FRONT OF HER
PORTRAIT, 1970.

DAVID HOCKNEY PAINTING CELIA
BIRTWELL, 1970.

Patrick Proctor was a dear old friend of David Hockney's and a fabulous watercolorist and quirky portrait painter. He was very tall, very thin, and a flamboyant storyteller. On my first visit to Europe, the three of us drove around France and Italy in David's tiny Morris Minor, and since I stubbornly insisted on sitting in front, poor Patrick had to scrunch up his long legs in the back.

Ossie Clark and Celia Birtwell epitomized the London fashion scene. Ossie was a brilliant designer and cutter—he made my python jacket—and Celia's prints gave his clothes a soft, romantic look. In an era of outrageous dressing, they and their clothes stood out. They were opposites who complemented each other. She liked to stay at home, and he loved parties. David painted one of his Gothic double portraits, *Mr. and Mrs. Clark and Percy,* in their flat in Linden Gardens.

OPPOSITE: PATRICK PROCTOR, STOURHEAD, 1968. ➤

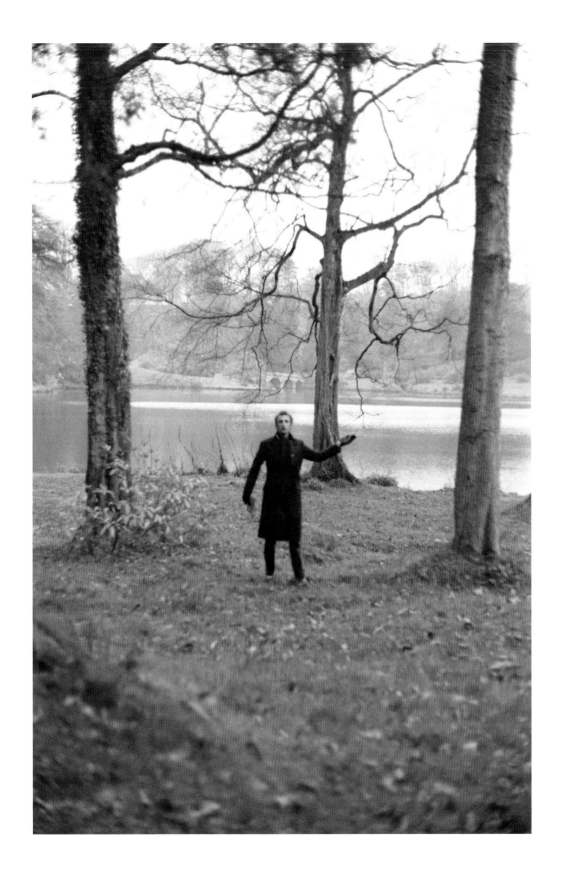

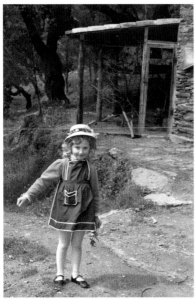

JOELY RICHARDSON, 1969.

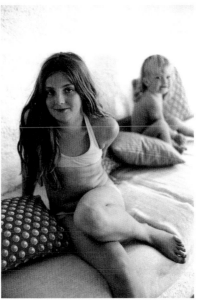

NATASHA RICHARDSON, 1974.

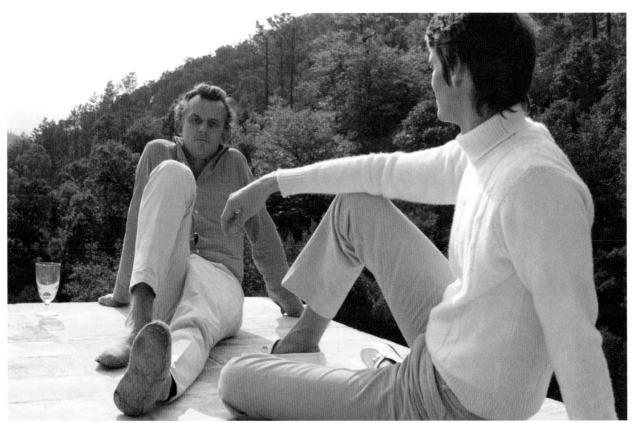

TONY RICHARDSON AND BILLY MCCARTY-COOPER, 1969.

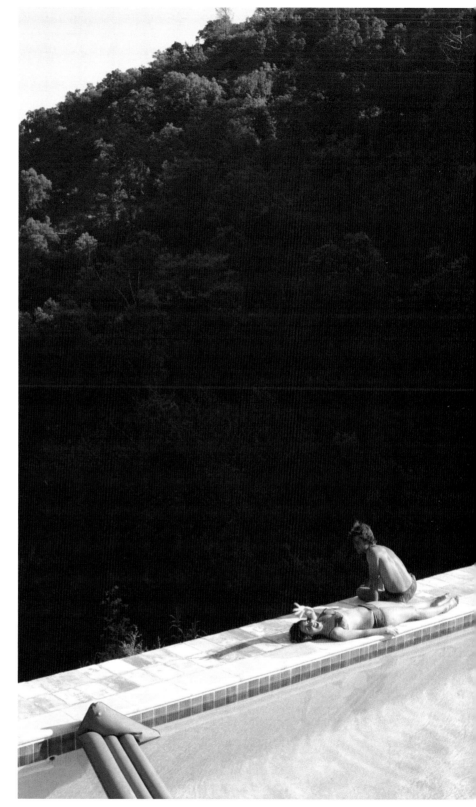

Le Nid du Duc was an abandoned little village in a quiet valley in the hills above Saint-Tropez. The great director Tony Richardson bought it and turned it with enormous flair into a magical compound of houses and guesthouses. It was always filled with friends, whether he was there or not. He could be cruel or incredibly charming, directing the house party as he would one of his plays or movies, and he loved guests who performed well. No extrovert, I failed the audition and he took a great dislike to me.

THE POOL, LE NID DU DUC, 1969.

OVERLEAF: PATRICK PROCTOR, LE NID DU DUC, SAINT-TROPEZ, 1968.

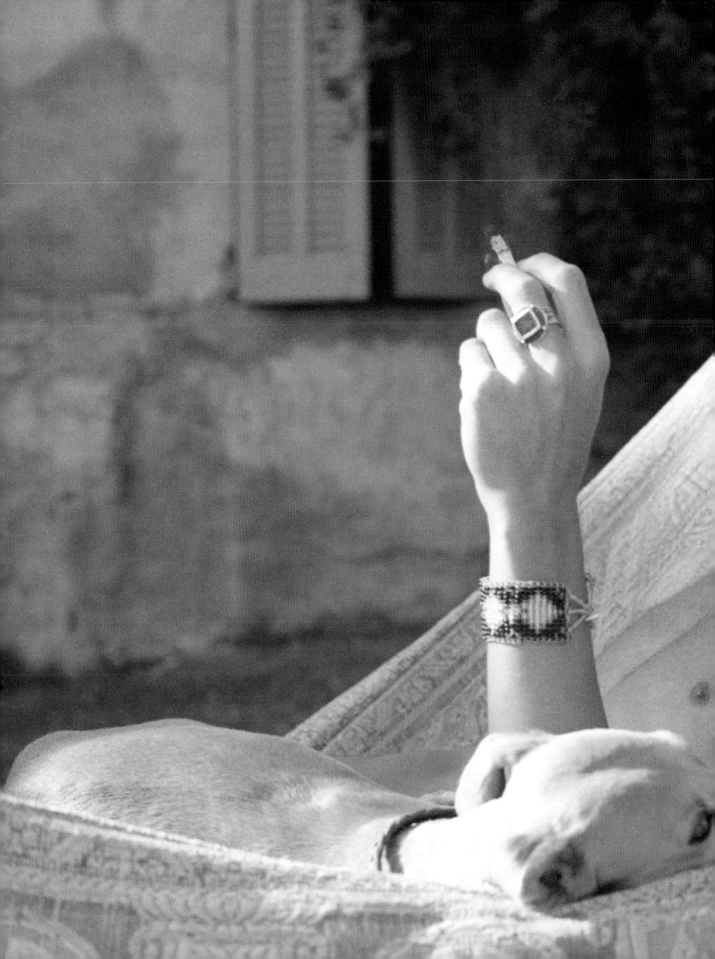

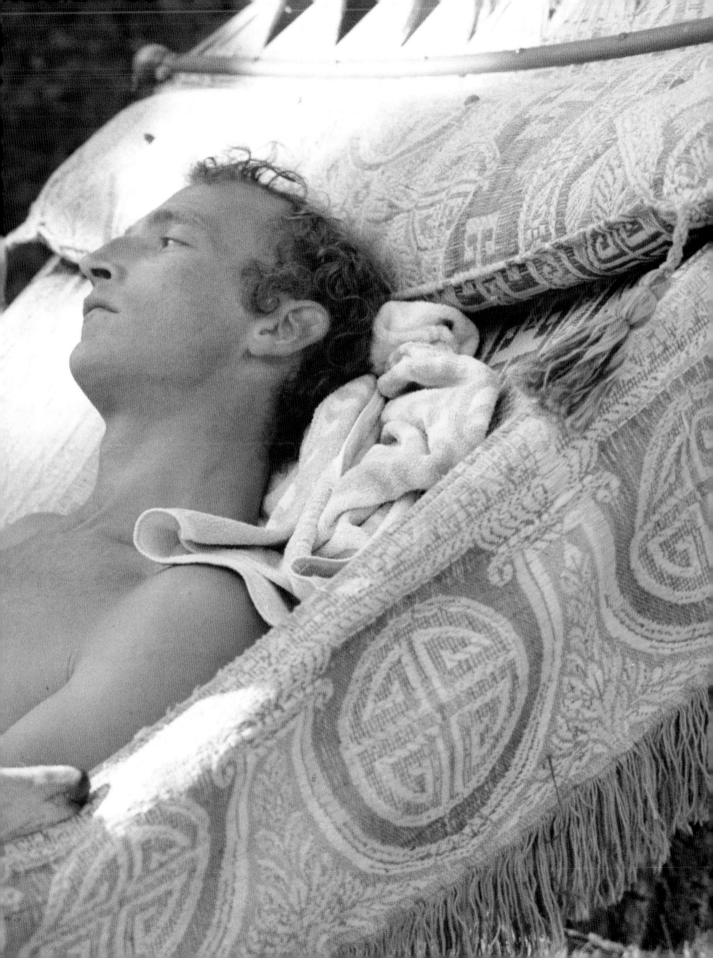

DAVID HOCKNEY, PARIS, 1969.

The idea of the Grand Tour intrigued us, and we took many trips to the Continent—as the insular British call the rest of Europe—to visit museums or take the waters at the legendary spas. Karlovy Vary and Mariansky Lazne, the former Carlsbad and Marienbad, were then part of the Communist block, so the luxurious shopping arcades were shuttered and the once-grand restaurants were cafeterias for the proletariat. Yet their faded nineteenth-century glamour was hypnotic. Venice was another trip entirely.

DAVID HOCKNEY, VIENNA, 1969.

OPPOSITE: DAVID HOCKNEY, VENICE, 1970. ➤

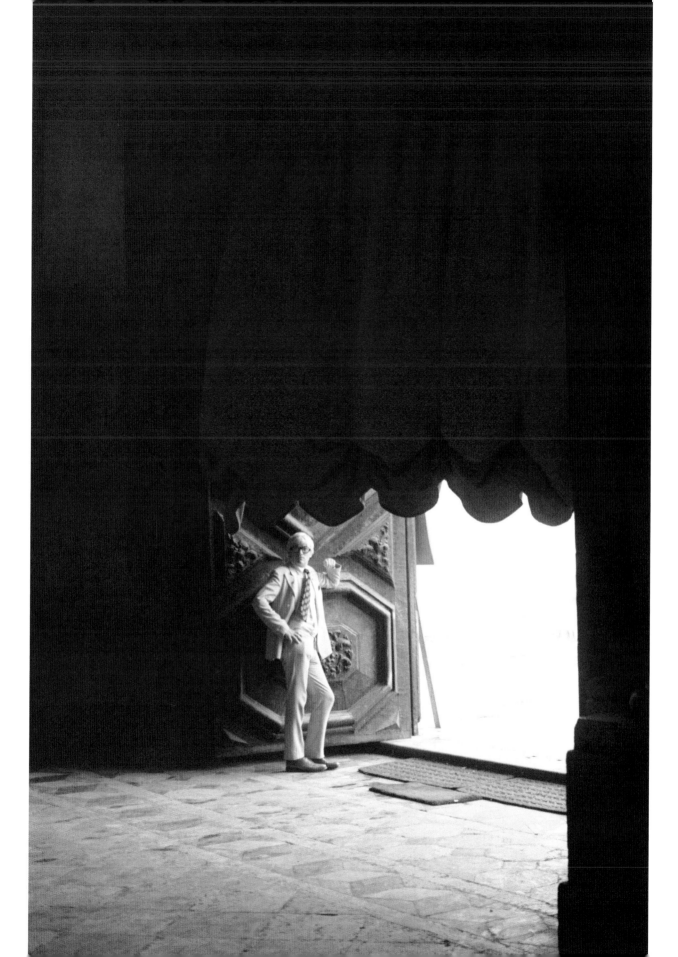

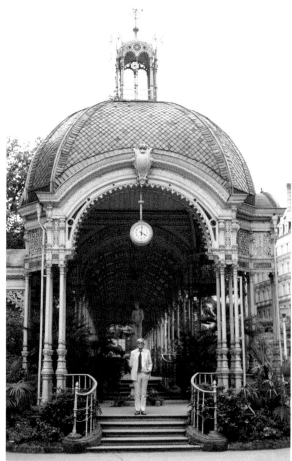

CARLSBAD, 1970.

The French spas were still grand and frequented only by the French. We stayed at the Pavillon Sevigne at Vichy many times, often with friends in tow.

DAVID HOCKNEY, PAVILLON SEVIGNE, VICHY, 1970.

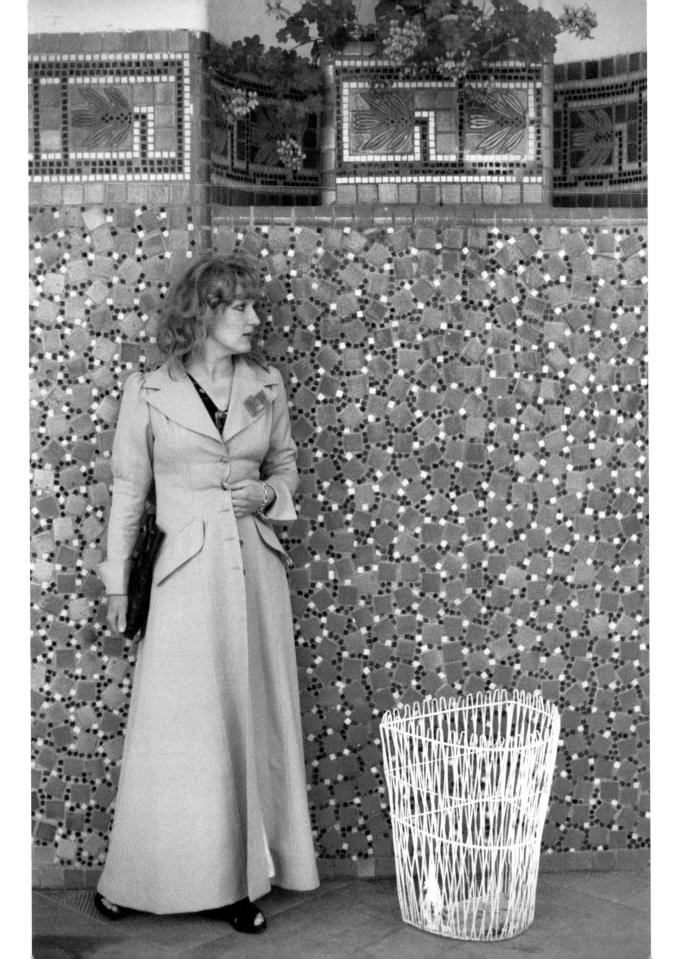

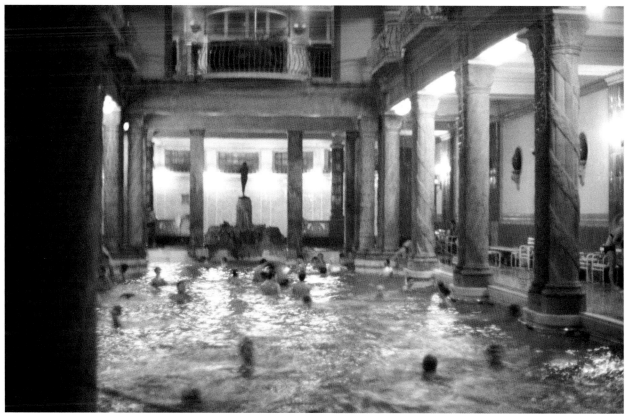

HOTEL GELLERT, BUDAPEST, 1970.

On one of these trips, we sailed down the Danube from Vienna to Belgrade, drinking homemade slivovitz with friendly Czechs and Slovaks, the only other tourists on the fairly seedy boat, and stopping in Budapest to see the mineral pool at the Hotel Gellert.

MARIENBAD, 1970.

⤚ OPPOSITE: CELIA BIRTWELL, CONTREXEVILLE, 1970.

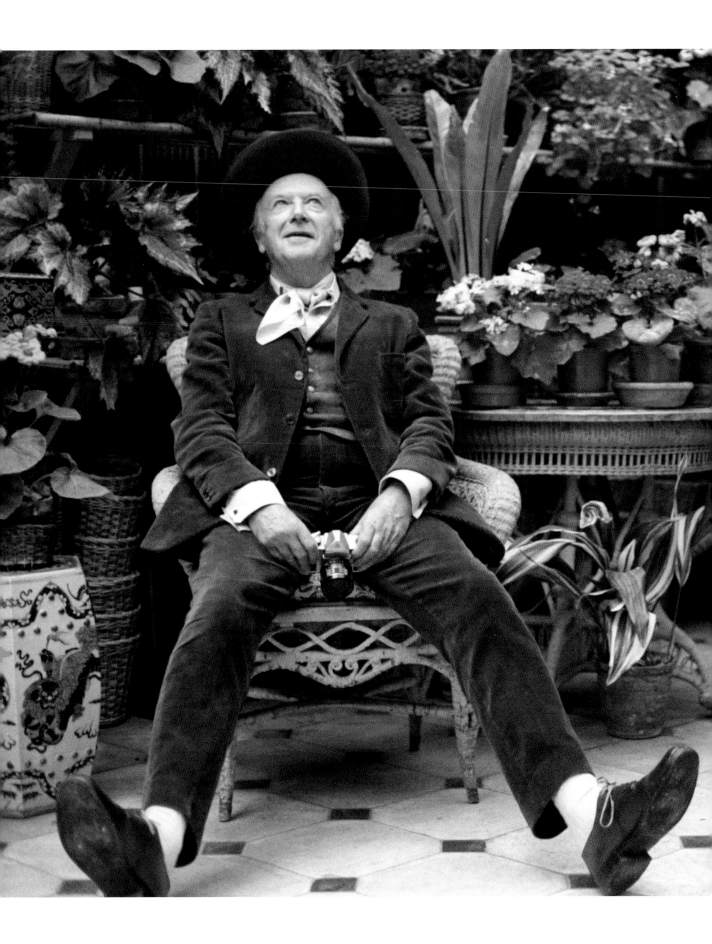

STILL LIFE, REDDISH HOUSE, 1970.

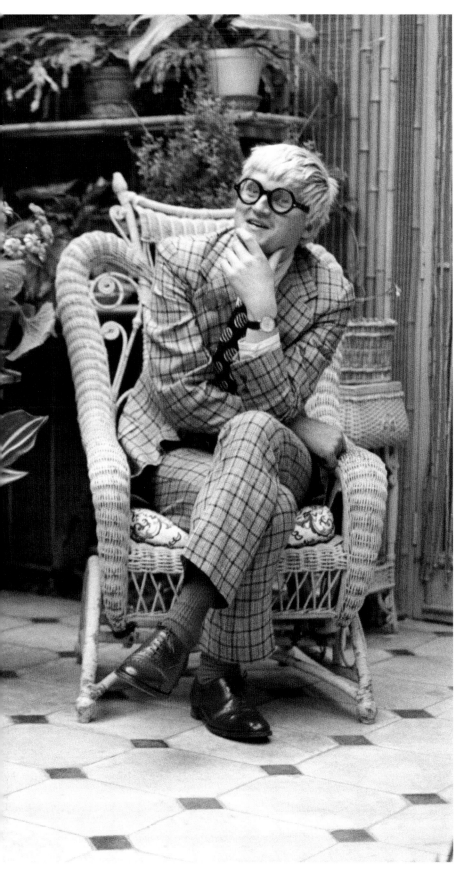

David Hockney and I spent many weekends at Cecil Beaton's country house in Wiltshire. It was called Reddish House and was partly real Edwardian and partly a theatrical creation of Cecil's. He had kept scrapbooks for years, which he let me look through, and they were an inspiration for my own albums. Cecil was an amusing, glamorous, and sharp-tongued dandy who in his diaries said, "the boys were well-behaved"—a great compliment.

DAVID HOCKNEY AND CECIL BEATON, REDDISH HOUSE, 1970.

RUDOLF NUREYEV AND FILM DIRECTOR WALLACE POTTS, 1970.

Lindy Dufferin was a friend of Sir Frederick Ashton, and she took David Hockney and me to draw Rudolf Nureyev at the Royal Ballet rehearsal studios. Since the powers above wouldn't let me in the studios, I had to wait outside the door. There I met the dancer Wayne Sleep, and we immediately became the best of friends. Rudolf's house on the outskirts of London was filled with enormously overscaled furniture, "less likely to be stolen," he cannily explained with Russian peasant logic.

OPPOSITE: WAYNE SLEEP, PARIS, 1970. ➤

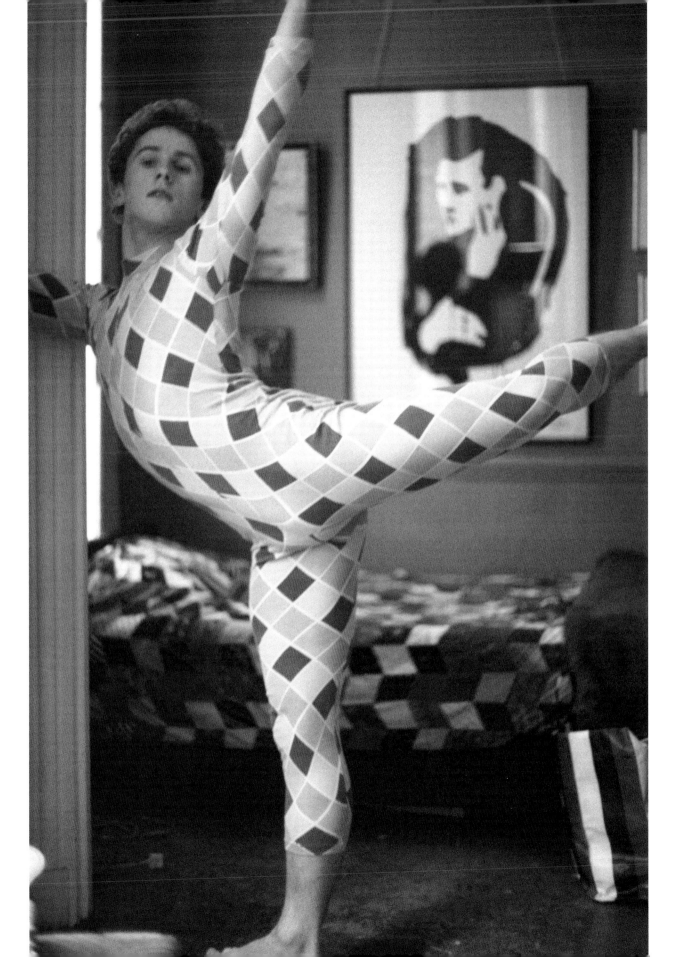

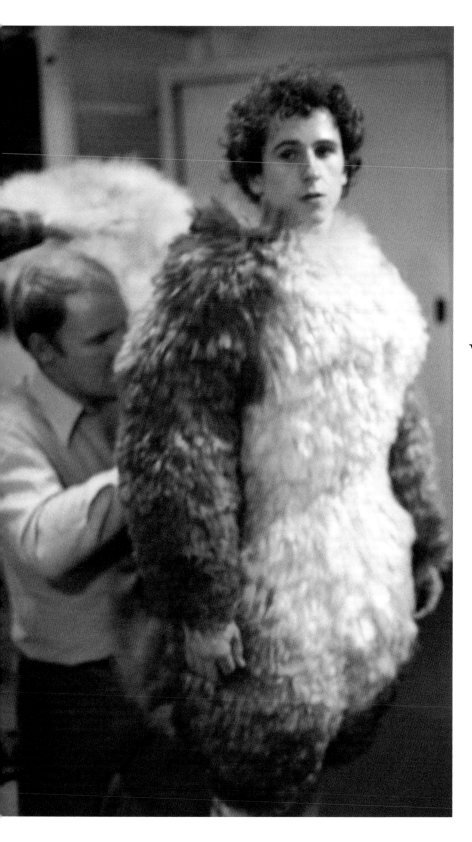

Wayne Sleep, a brilliant dancer with the Royal Ballet, is in the Guinness Book of World Records for doing more entrechats than Vaslav Nijinsky, and he would have been a romantic lead had the ballerinas not towered above him. He frequently let me watch rehearsals from backstage at the Royal Opera House, and also the filming of Sir Frederick Ashton's wonderful *Tales of Beatrix Potter*. In this romantic evocation of rural England, Wayne danced the role of Squirrel Nutkin. Sir Fred and character dancer Alexander Grant demonstrated rodent behavior for me and my camera.

WAYNE SLEEP, 1970.

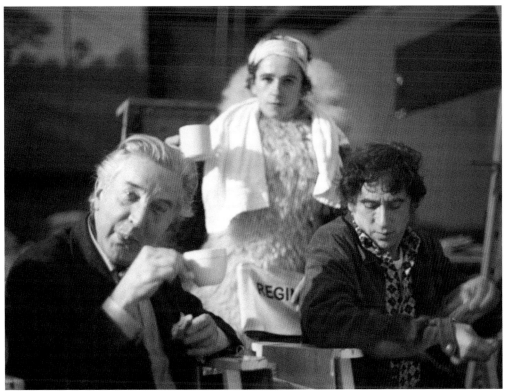

SIR FREDERICK ASHTON, WAYNE SLEEP, AND ALEXANDER GRANT, 1970.

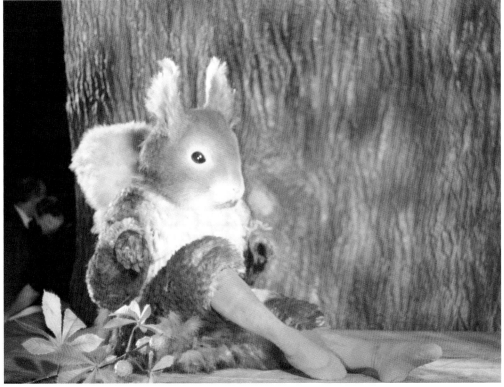

WAYNE SLEEP, 1970.

With two friends, the painters Mark Lancaster and Julian Lethbridge, I flew to Brussels to visit Baron Leon Lambert who ran Banque Lambert. Its headquarters were designed by Gordon Bunshaft and towered over the palace of the baron's schoolmate King Baudouin. The baron lived in the exquisite and classically modern penthouse of such baronial proportions that he confessed to not knowing where the cellar was, as he dispatched his butler for a bottle of Chateau Yquem. He had inherited a great collection of Impressionist art from his Rothschild mother and added contemporary works to it.

MARK LANCASTER, BRUSSELS, 1970.

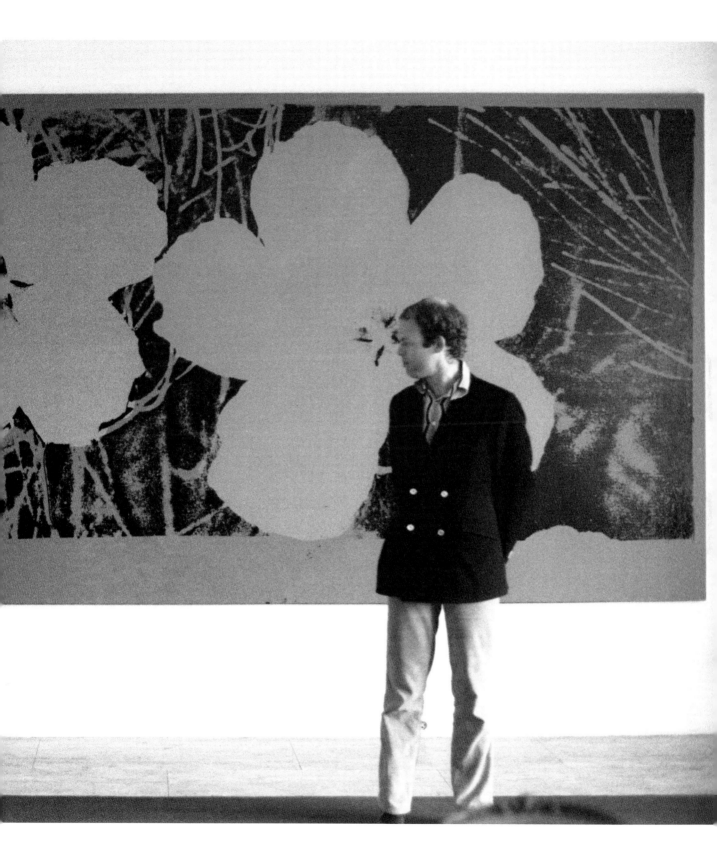

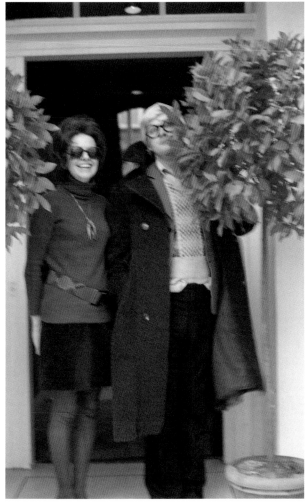

MARGUERITE LITTMAN AND DAVID HOCKNEY, LONDON, 1970.

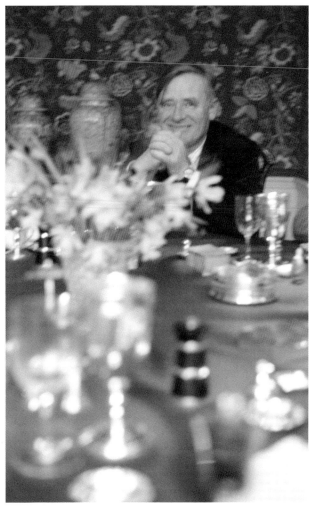

CHRISTOPHER ISHERWOOD, LONDON, 1970.

Marguerite Littman was a belle from Louisiana who taught Elizabeth Taylor to drawl like her for *Cat on a Hot Tin Roof*. She knew everybody, as her friend Tennessee Williams used to say, and had introduced Christopher Isherwood to Don Bachardy. She gave famous luncheons with the best food, drink, and conversation that lasted until late in the afternoon, by which time you were good for nothing but a nap. David Hockney's portrait of Chris and Don hung in her dining room, where

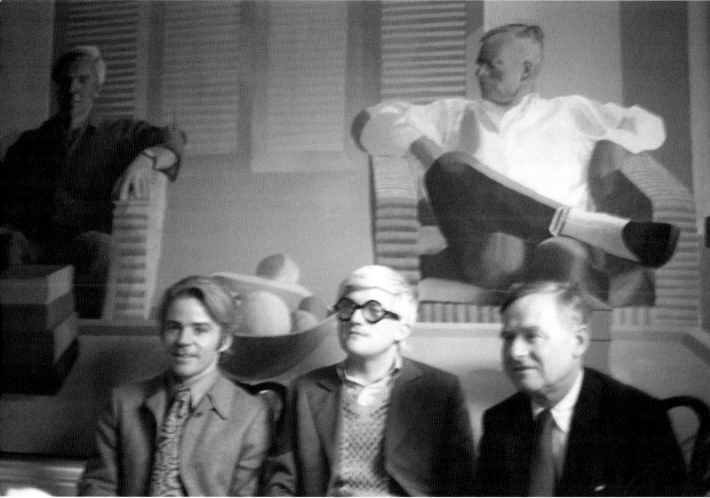

DON BACHARDY, DAVID HOCKNEY, AND CHRISTOPHER ISHERWOOD, LONDON, 1970.

the walls were covered in the same red flowered fabric that Billy Baldwin had used for Diana Vreeland's living room.

At one lunch, Natalie Wood told us how to eliminate a double chin in profile and how to quiver it to cry, tricks I tried to use a few years later while trying to act in Jack Hazan's film about David, *A Bigger Splash,* but to no avail.

One weekend Cecil Beaton called his childhood friend, the reclusive poet Stephen Tennant, to see if we could pay him a visit. He hadn't left his bedroom for years, so Cecil was delighted when he said yes. Stephen's wealthy mother had published his poetry when he was still a precocious schoolboy, and he had been an early influence on Cecil. Wilsford Manor was in a state of poetic dereliction, draped in spider webs. With flowing hennaed locks, Stephen received us in bed, serving champagne and singing campy old music-halls songs with backup by his butler, George.

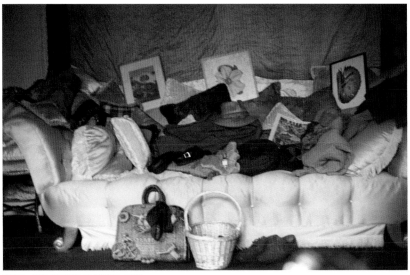

SOFA, WILSFORD MANOR, 1970.

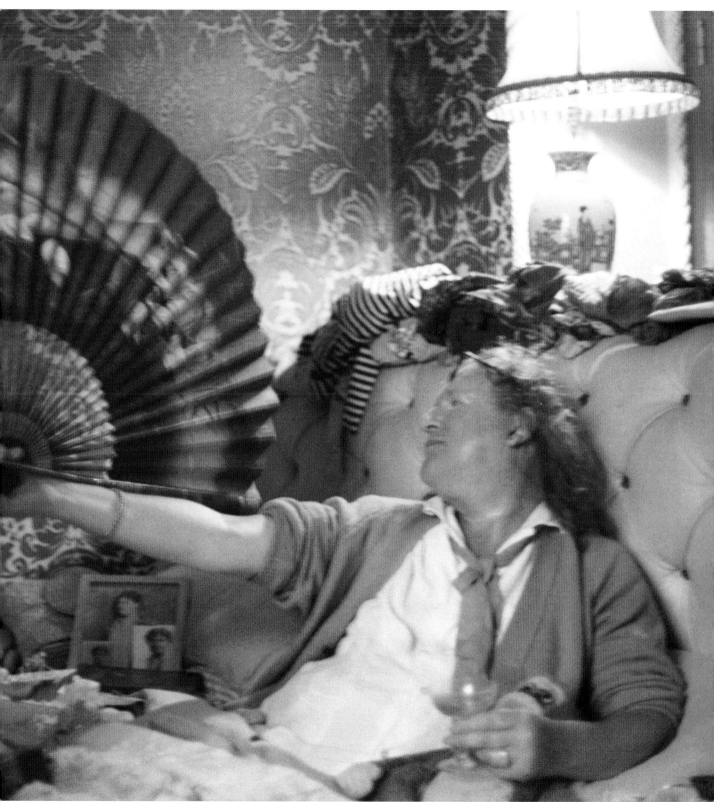

STEPHEN TENNANT, WILSFORD MANOR, 1970.

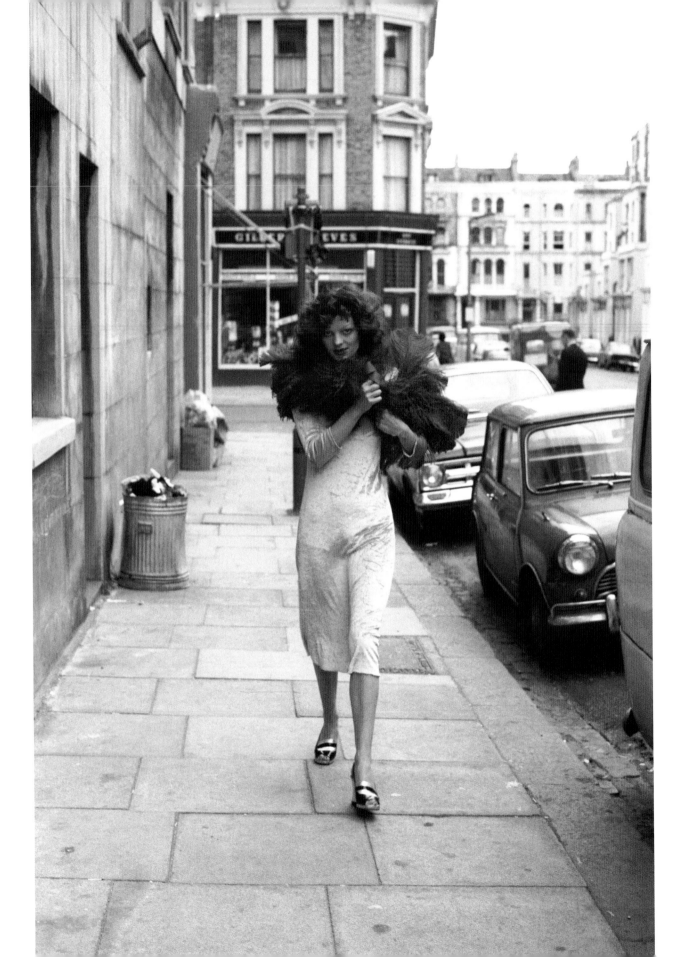

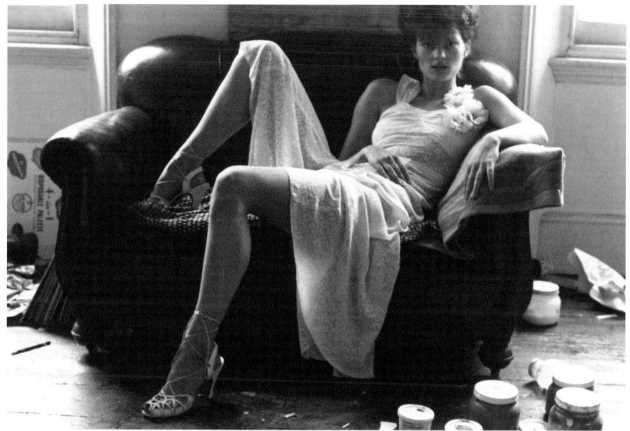

GALA MITCHELL, COLVILLE SQUARE, 1971.

The mysterious and eccentric Gala Mitchell was a cult model and favorite of Ossie Clark, designer Antony Price, and me. We became good friends and I painted her a number of times. One of the paintings looked quite a bit like the photograph of her on the couch, without the jars.

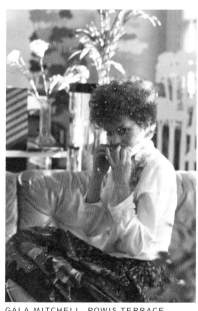

GALA MITCHELL, POWIS TERRACE, LONDON, 1971.

◁ OPPOSITE: GALA MITCHELL, COLVILLE TERRACE, 1970.

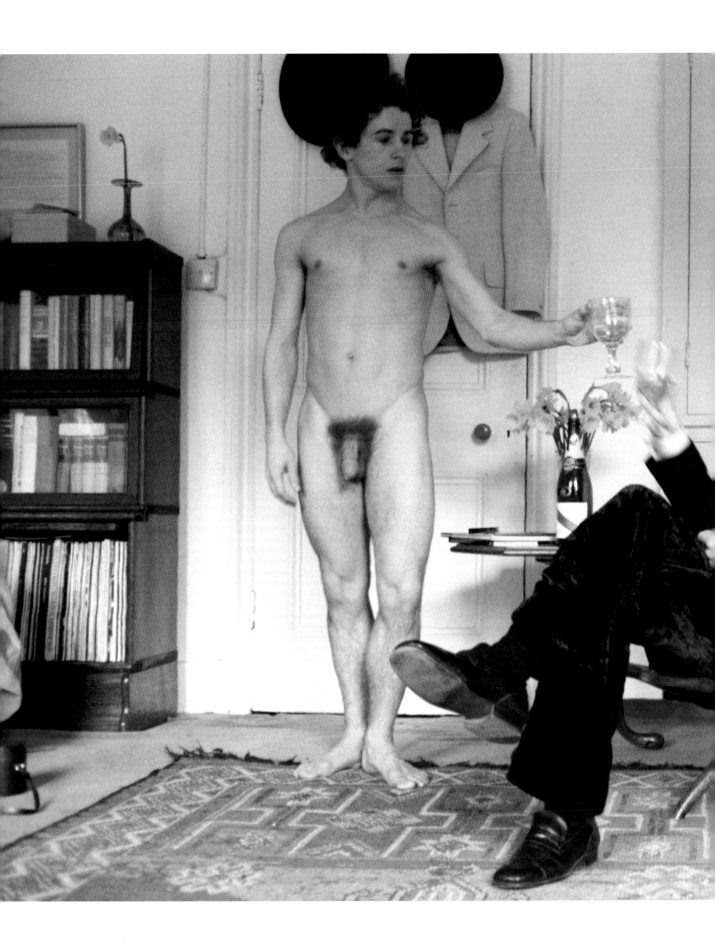

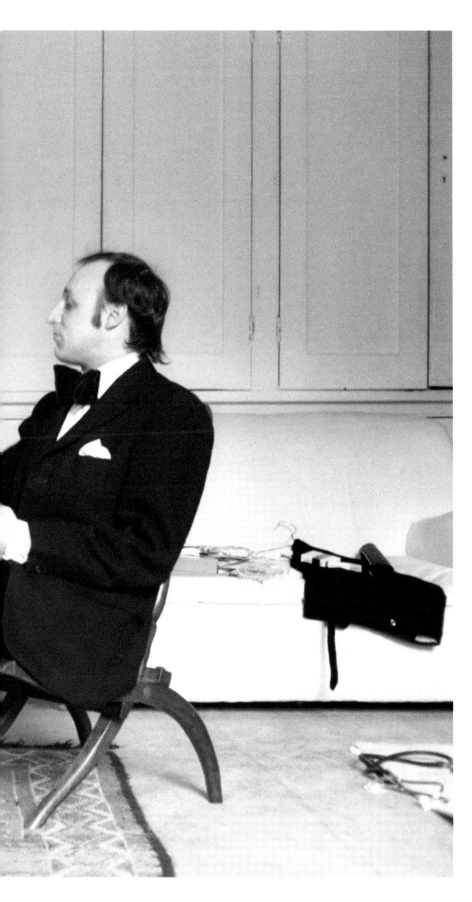

For a painting I thought of doing, but never did, I photographed Wayne Sleep and his friend George Lawson, a brilliant antiquarian bookseller, at their flat in Wigmore Place. This remaining image gives an idea of our playful times together. David Hockney used to joke that Wayne had the body and George had the brains, but it was not so simple.

WAYNE SLEEP AND GEORGE LAWSON, WIGMORE PLACE, 1971.

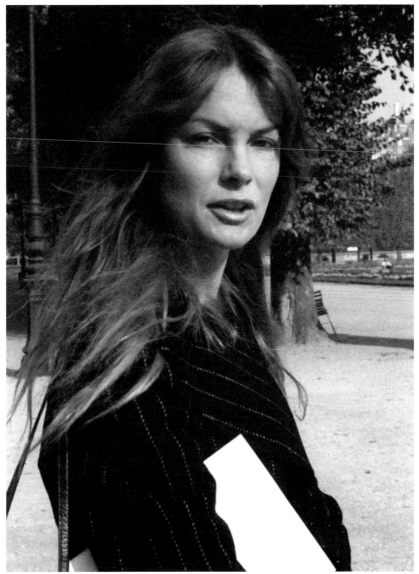

JEAN SHRIMPTON, PARIS, 1971.

Jean Shrimpton came with R. B. Kitaj to Paris to see the Matisse exhibition at the Grand Palais. I struggled to get a picture of her as she kept turning away with the sixth sense of experience. Finally I got this rather angry look. I think she didn't feel beautiful any longer, but I did not agree.

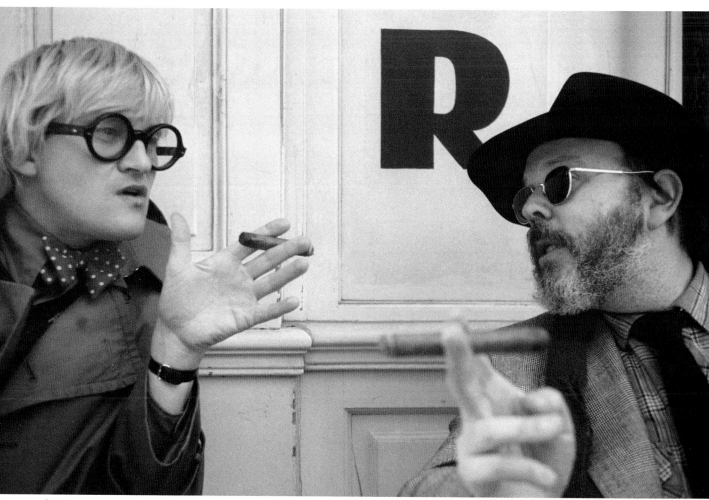

DAVID HOCKNEY AND HENRY GELDZAHLER, CAFÉ DE FLORE, PARIS, 1972.

Everyone visiting Paris in those days would stroll along the Boulevard Saint-Germain to the Café de Flore to see who was in town. Henry Geldzahler, the visionary curator of twentieth-century art at the Metropolitan Museum in New York came to Paris often to shop for its department of decorative arts. He was outrageous, witty, and vain—and loved or loathed. A firm believer that "bad art is bad for you," he claimed to have suggested to Andy Warhol to do paintings of soup cans.

JACQUES-HENRI AND HENRIETTE LARTIGUE, 1971.

When the English first discovered the south of France, they would go there in the winter. Now mobbed in the summer, it was during the winter months that the absence of crowds revealed its serene beauty and crystalline light, which had attracted so many artists.

One wintry day, Tony Richardson drove us to Biot in the hills above Cannes to the house of Jacques-Henri Lartigue, where his wife,

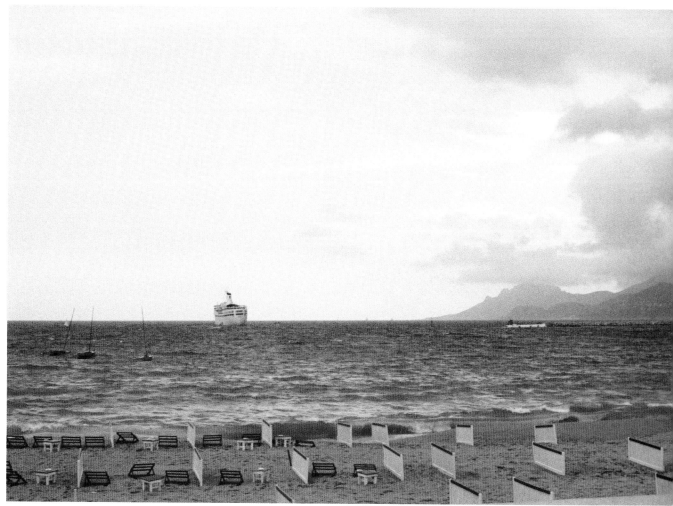

SHIP, CANNES, 1971.

Henriette, and her mother had cooked lunch. Jacques-Henri was a charming man who dressed like a young mod. His photography had recently been discovered and published to great acclaim; *Diary of a Century* was a brilliant documentation of his milieu and a great influence on what I was trying to do with my own photographs.

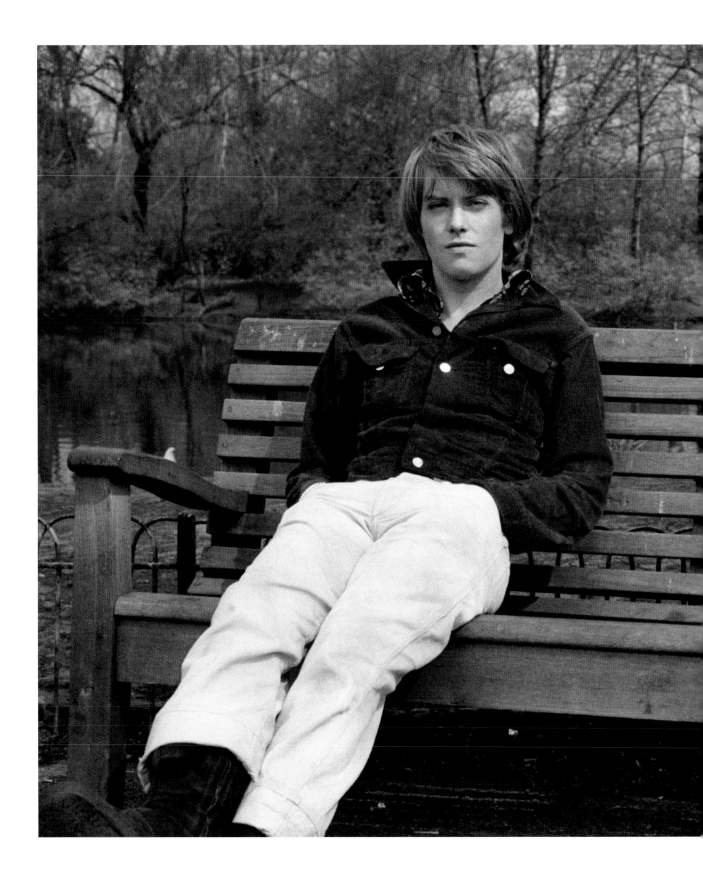

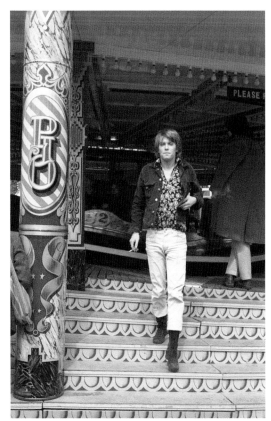

ERIC BOMAN, BATTERSEA FUN FAIR, 1971.

Arriving at the restaurant Mr. Chow to have dinner with Andy Warhol's grandiose and amusing manager, Fred Hughes, I had no idea what was in store for me. Fred had come to London with Paloma Picasso to see Visconti's *Death in Venice,* and they were an hour late, so I got acquainted with the other guests, Manolo Blahnik and Eric Boman. Manolo was not yet a shoe designer, but it was obvious that he would become something extraordinary—he was bursting at the seams with energy and ideas. Eric was then an illustrator and fabric designer. The friendships begun that night started another chapter in my life. Manolo and Paloma became great friends, and Eric my lover.

ERIC BOMAN, BATTERSEA PARK, 1971.

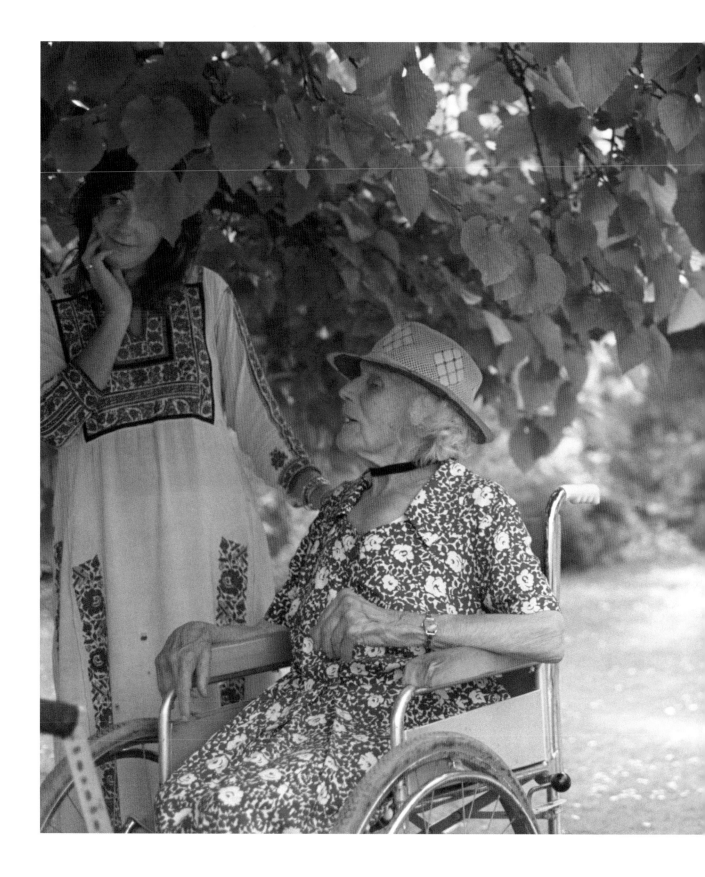

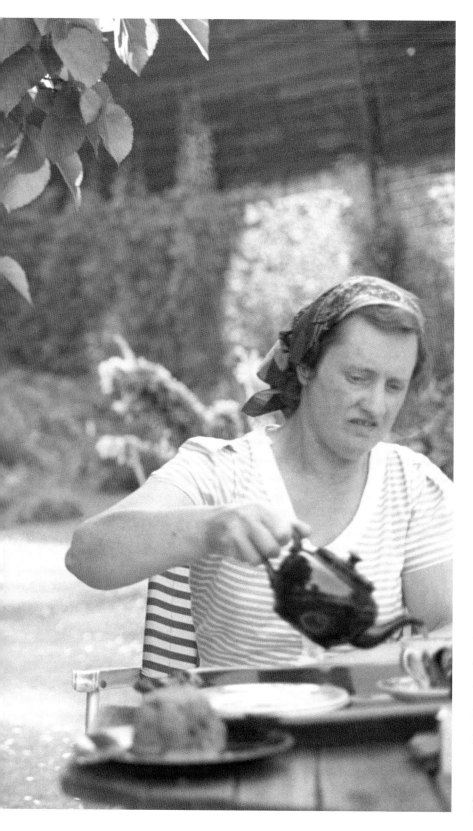

The North sisters, Mary and Melissa, although half-American, were quintessentially English. Their American mother lived in the country with their father's ninety-year-old aunt, Duss, in an idyllic setting only forty-five minutes from London. Aunt Duss was an artist known as the best copyist of her day. She would go to impoverished country houses to copy the family portraits before they had to be sold off to American museums, and was considered particularly good at Romney.

MELISSA NORTH AND AUNT DUSS, SMALL DEAN, 1971.

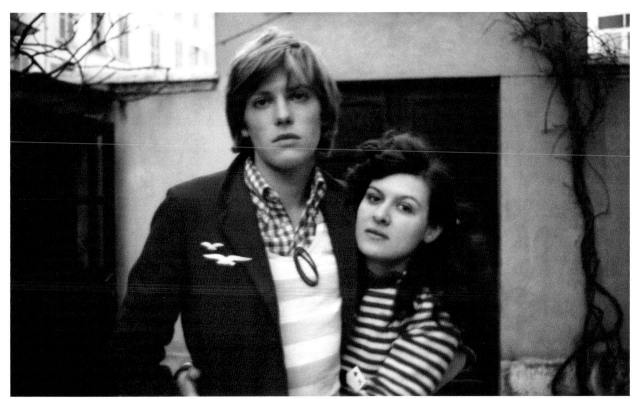

ERIC BOMAN AND PALOMA PICASSO, PARIS, 1971.

Paloma Picasso lived in her grandmother's nineteenth-century house in
Neuilly surrounded by a camellia garden and a bamboo grove on a tiny
plot. Once Eric Boman and I stayed there and I was photographing him
and Paloma when she stumbled down the front steps in her wedgies
and lay giggling on the gravel, not realizing she had broken her foot.

OVERLEAF: OSSIE CLARK, CARRENAC, 1971.

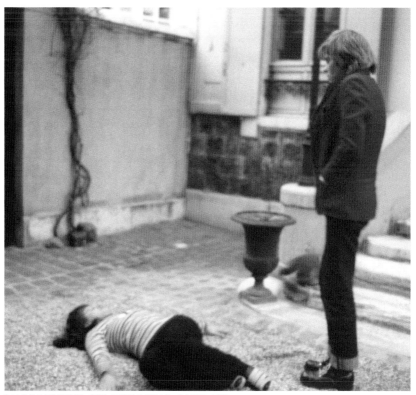

PALOMA PICASSO AND ERIC BOMAN, PARIS, 1971.

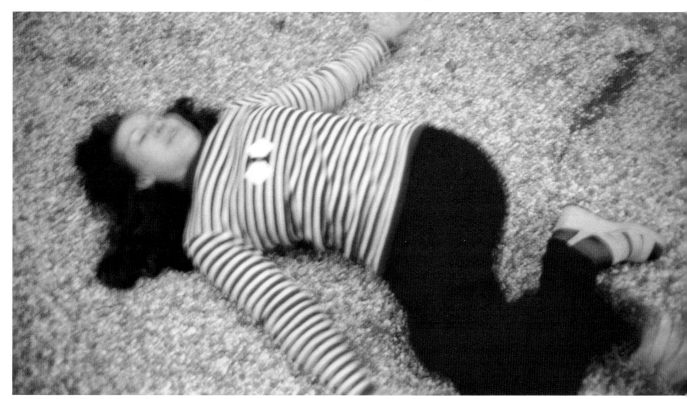

PALOMA PICASSO, PARIS, 1971.

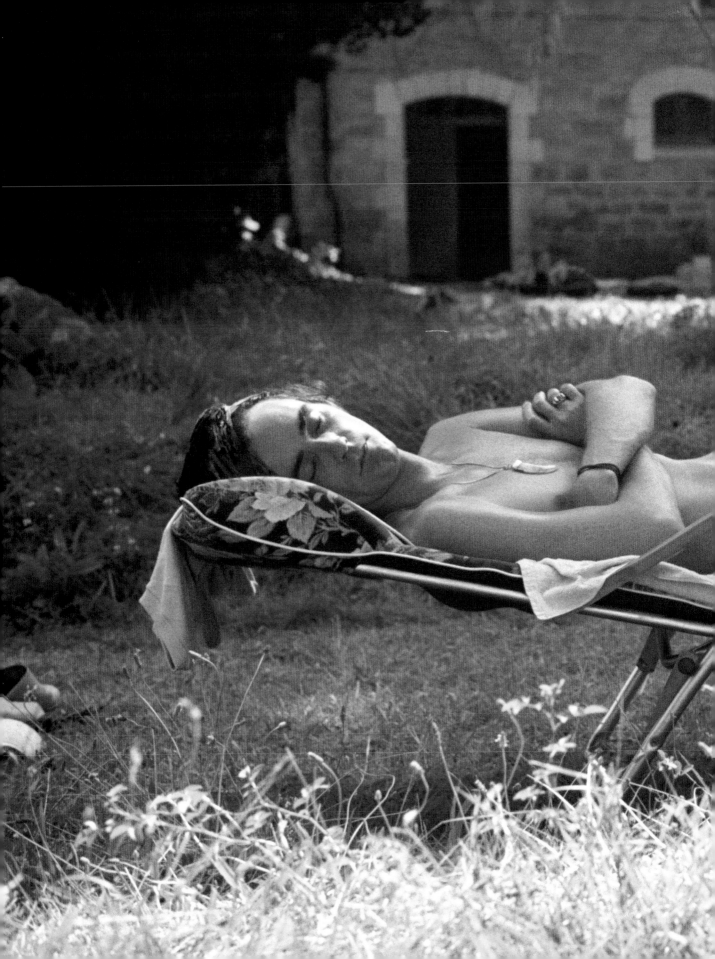

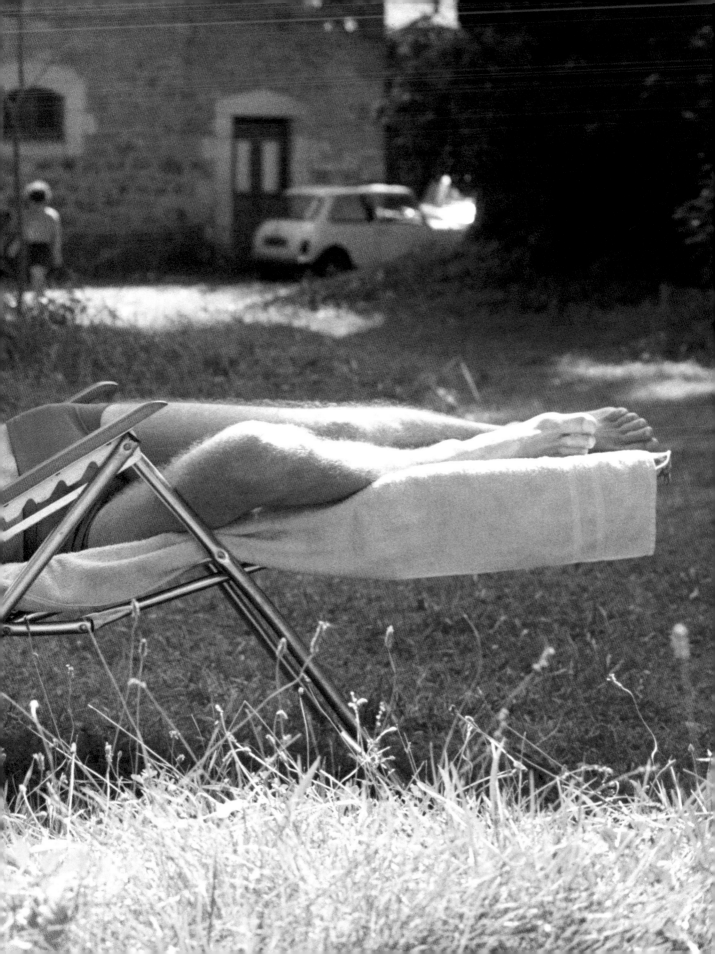

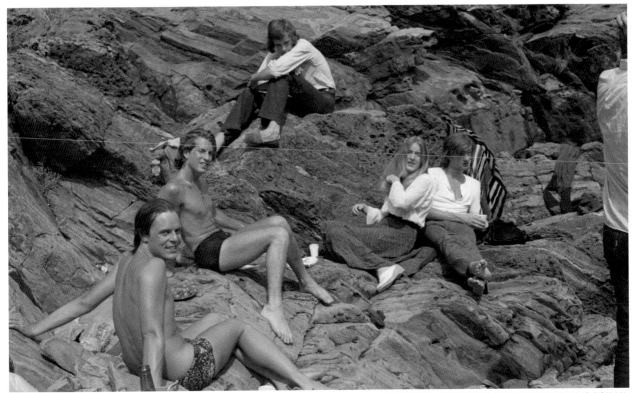

JULIAN LETHBRIDGE, PETER SCHLESINGER, CATHERINE GUINNESS, AND JASPER GUINNESS, CADAQUES, 1971. PHOTO BY ERIC BOMAN.

During the summer of 1971, the usual caravan of friends went to stay at the small Chateau de Carrenac in the Dordogne that Kasmin and his Francophile wife, Jane, rented. George Lawson and Wayne Sleep drove all the way from London in their open toylike car named "Noddy," arriving shaken and burnt to a crisp. David Hockney and I later went on to Barcelona and Cadaques, joining Mark Lancaster, Julian Lethbridge, and Eric Boman. Mark had rented Marcel Duchamp's old flat—where Duchamp had made *Bouche-Evier,* a lead sculpture cast from the sink plug—from his widow, Teeny. Other neighbors were Richard Hamilton and his girlfiend, Rita, and a houseful of Guinnesses. From there, I went with Catherine Guinness, Dom Hamilton, and Eric along the Riviera in Ossie Clark's Bentley Continental, the most beautiful car of all time, hoping to spend the night at Tony Richardson's. He would have none of it, so we went on to Ossie's pals Mick and Bianca Jagger near Cannes, where arriving at midnight we devoured an entire Paris-Brest pastry, meant for the next day's lunch.

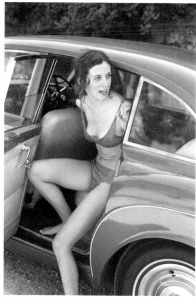

DOM HAMILTON, BIOT, 1971.

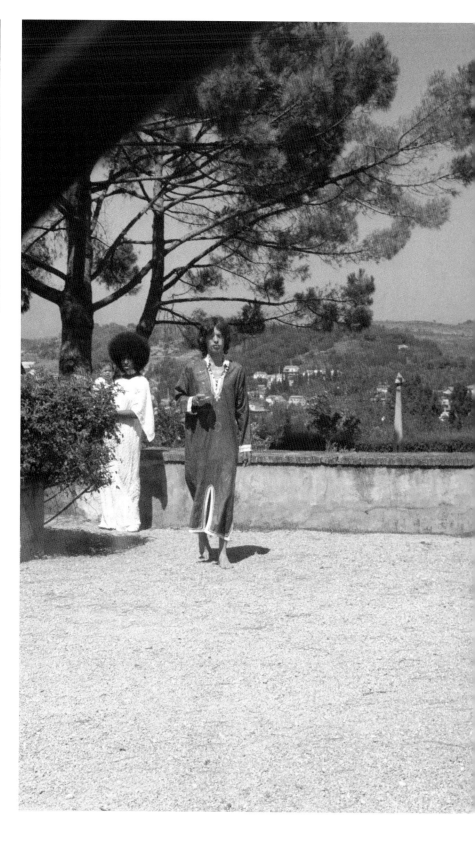

MICK JAGGER AND
MARSHA HUNT, BIOT, 1971.

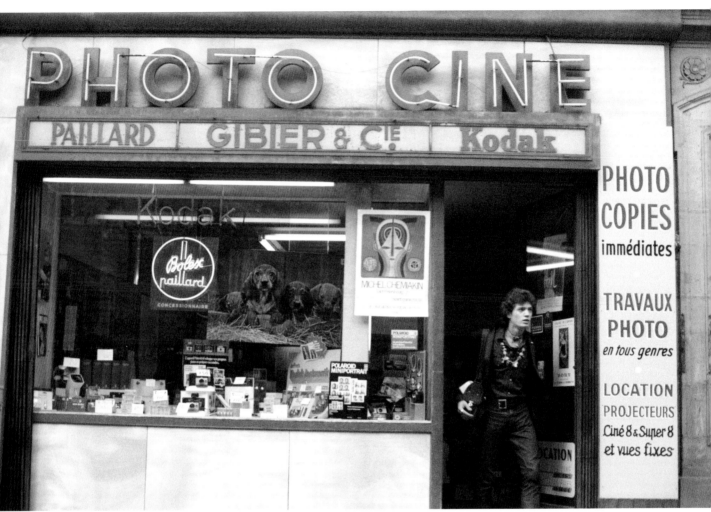

ROBERT MAPPLETHORPE, PARIS, 1971.

Composing a picture of a photographic shop on the Boulevard Saint-Germain, I noticed a handsome young man going in and pressed the shutter as he came out. Years later, in New York, a friend looked through my albums and recognized him as Robert Mapplethorpe, by then a famous photographer.

OPPOSITE, TOP TO BOTTOM: ST. CERE, FRANCE, 1971; LONDON, 1971; MUNICH, 1972. ⟩

ABOVE AND BELOW: MANOLO BLAHNIK AND ERIC BOMAN, COLVILLE TERRACE, 1972.

When I left David Hockney in 1971, I moved to a studio flat in a house in Colville Terrace. Manolo Blahnik moved into the top two floors of the same house a few months later. His place was all white and spare except for carefully placed furniture and objects, each one distinct in some way. Manolo, who had never cooked before, would make Canary

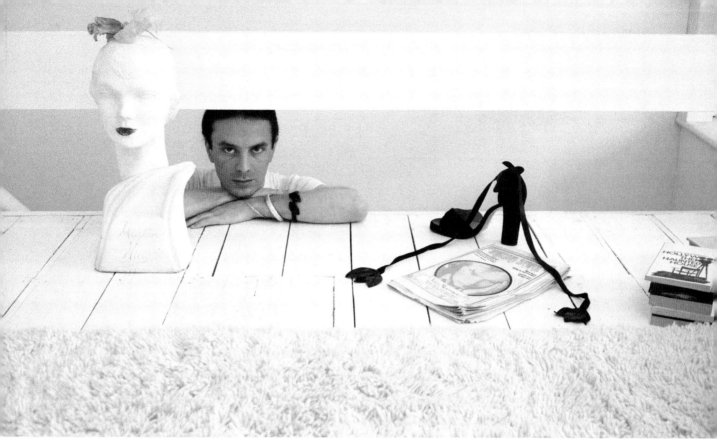

MANOLO BLAHNIK, COLVILLE TERRACE, 1972.

Island rice and beans and blender daiquiris, and we would watch old movies or listen to the Spanish singers he loved, laughing until we ached.

Manolo wanted to photograph Paloma Picasso in his flat but was too impatient for the technicalities involved and enlisted me as his "assistant." In the end, I got this picture.

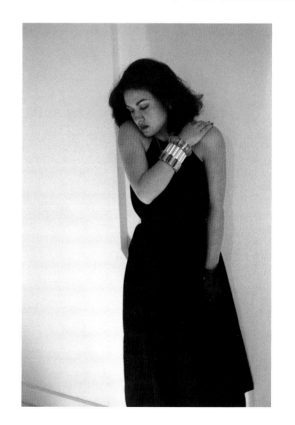

PALOMA PICASSO, COLVILLE TERRACE, 1972.

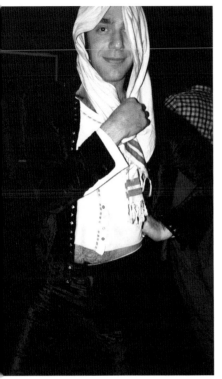

DEREK JARMAN, YOURS OR MINE,
1972.

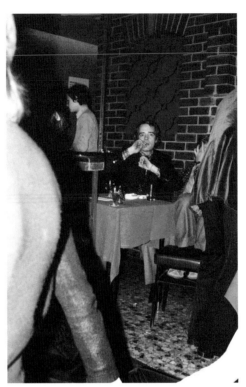

KIT LAMBERT, YOURS OR MINE, 1972.

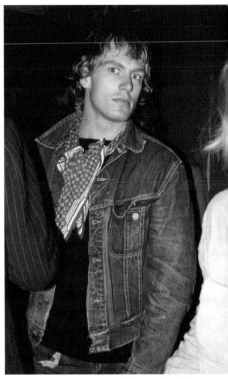

PETER HINWOOD, YOURS OR MINE, 1972.

No one ever went to the restaurant El Sombrero on Kensington High Street, but everyone went to the gay club Yours or Mine in its basement. You'd always see people you knew drinking cheap wine and dancing. One night, I found Peter Hinwood, the gorgeous monster of *The Rocky Horror Picture Show,* who was really an antiques dealer; Kit Lambert, the troubled producer of the Who and son of composer Constant Lambert; and the director Derek Jarman.

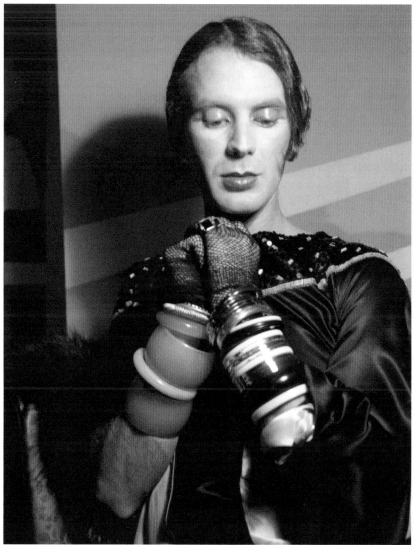

MANOLO BLAHNIK, 1972.

The Porchester Hall was a community center built in the nineteenth century where you could swim in an Olympic-sized pool, have a Roman style steam bath—or go to drag balls in its vast hall. I did all three. Manolo Blahnik went to one drag ball as Nancy Cunard after the Cecil Beaton portrait. Eric Boman went as a sexy Marilyn Monroe with dress and hips by Antony Price. A friend of Eric's since college, Antony was a fashion designer specializing in glamorous extravaganzas. Once I was Audrey Hepburn, wearing a cockerel-feathered hat I made myself and a green satin dress Antony made from an old Michael Fish scarf.

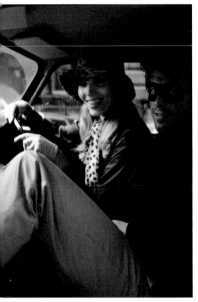

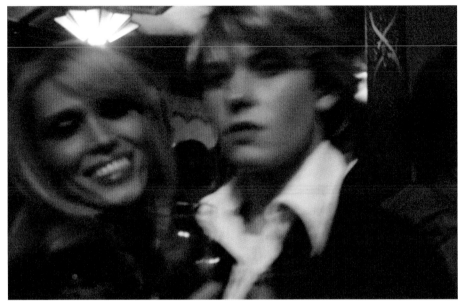

AMANDA LEAR AND ANTONY
PRICE, LONDON, 1974.

AMANDA LEAR AND ERIC BOMAN AT A ROXY MUSIC CONCERT, LONDON, 1973.

Showing off on my terrace, the smart and funny Amanda Lear was one of Salvador Dali's muses and modeled in Ossie Clark's shows before craftily transforming herself into a disco superdiva. She also appeared on a Roxy Music cover and on the stage with the group, all dressed by Antony Price.

OPPOSITE: AMANDA LEAR, COLVILLE TERRACE, 1973. ➤

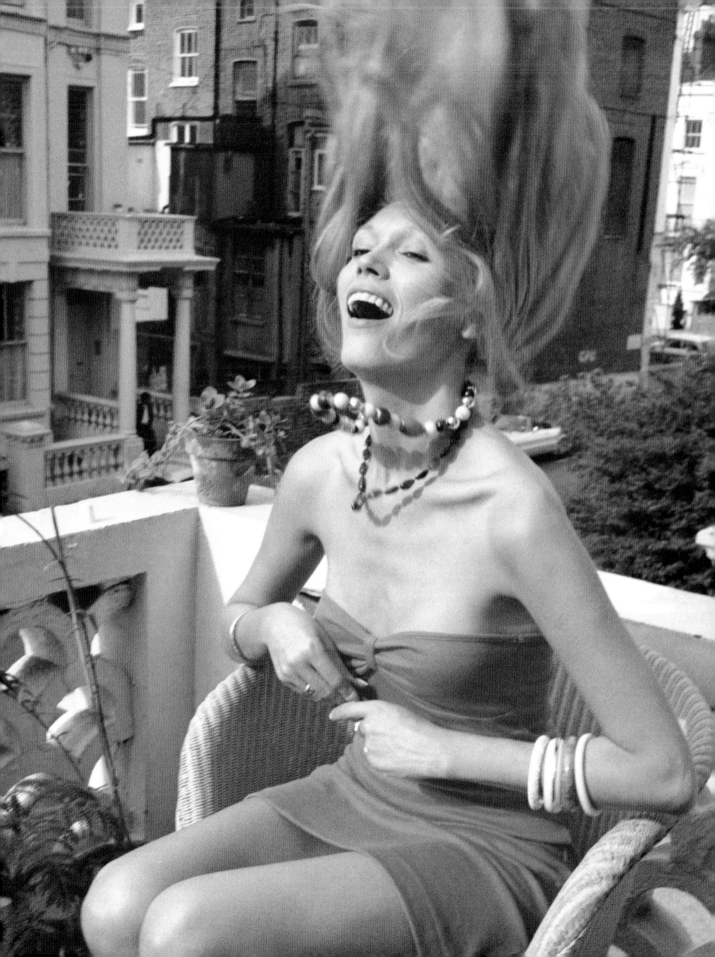

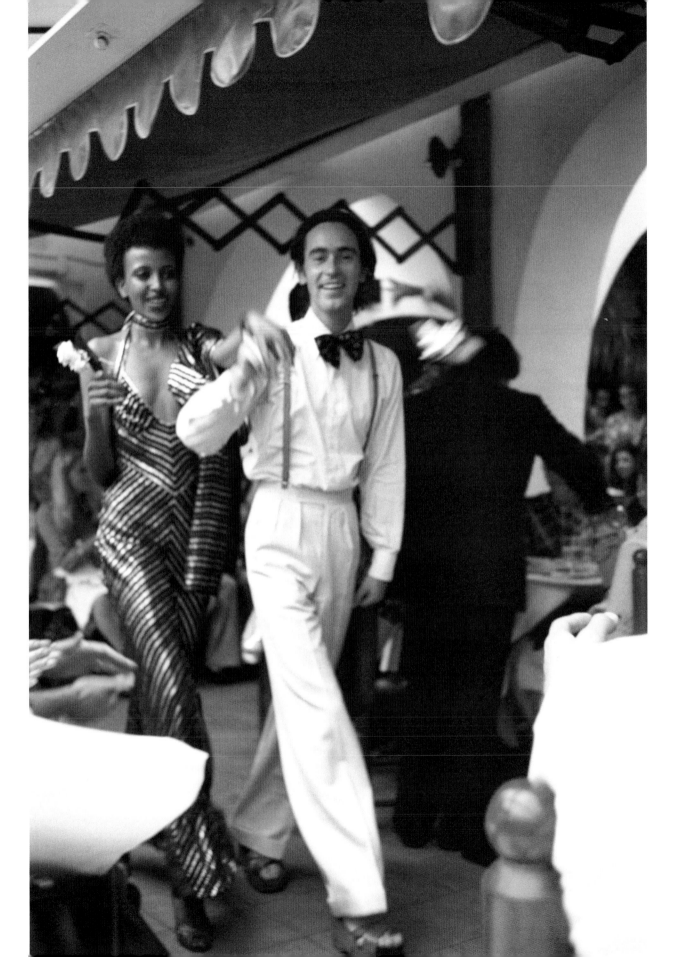

ERIC BOMAN, ULLA LARSON, AND JOAN JULIET BUCK, LONDON, 1973.

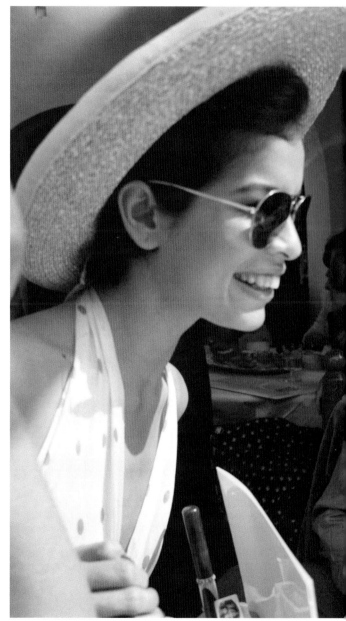

BIANCA JAGGER, LONDON, 1973.

Ossie Clark's fashion shows were glamorous
spectacles that brought together fashion, art, and
society. Amanda Lear, Gala Mitchell, and Beatle-wife
Patti Boyd were runway fixtures. His first one was on a
barge in Little Venice; others were held at the Chelsea
Town Hall and the Royal Court Theatre. Usually late
at night and never on time, they were fun and chaotic
affairs.

↖ OPPOSITE: OSSIE CLARK, LONDON, 1973.

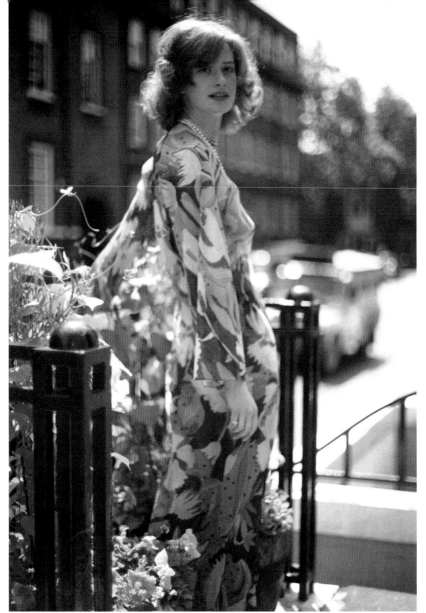

NICKY WEYMOUTH, LONDON, 1972.

Nicky Weymouth gave some of the liveliest parties in London, always lasting till dawn. She lived in the painter Augustus John's old studio in Chelsea, decorated by Christopher Gibbs in the "rich hippie style." Often without invitations or apparent planning, thirty people or more would show up. I usually went with Ossie Clark. In my painting of Nicky, she wore a dress he had designed in one of Celia Birtwell's most beautiful prints.

ISABEL STRACHEY AND VIOLET WYNDHAM, LONDON, 1973.

Violet Wyndham was the daughter of the writer Ada Leverson, whom Oscar Wilde nicknamed The Sphinx and who was his only friend when he left prison. Cecil Beaton said she wasn't half the man her mother had been, but I adored her. She lived around the corner from me in Notting Hill with her son Francis, a brilliant writer and critic. Her Portuguese cook, Maria, made delicious food for her own family downstairs while serving vile food for the likes of Princess Margaret, Roddy Llewellyn, Lady Diana Cooper, and the Jaggers upstairs. Isabel Strachey was a well-known novelist.

Violet Wyndham and I went many places together and made an odd couple of sorts. Once she invited me along to her friend Billy Whitaker's house for the weekend. Appropriately named Pylewell Park and inherited from his parents, it was unchanged since their day; his grown sister still lived upstairs in the nursery. The dessert peaches came from the hothouse, and the teacakes were fresh from the kitchen.

Cecil Beaton incorrectly but irresistibly called him Billy half-Whitaker. The other guests that weekend were Min Hogg, who hadn't yet founded *The World of Interiors,* and Spider Quennell, who had been married to the writer Peter Quennell.

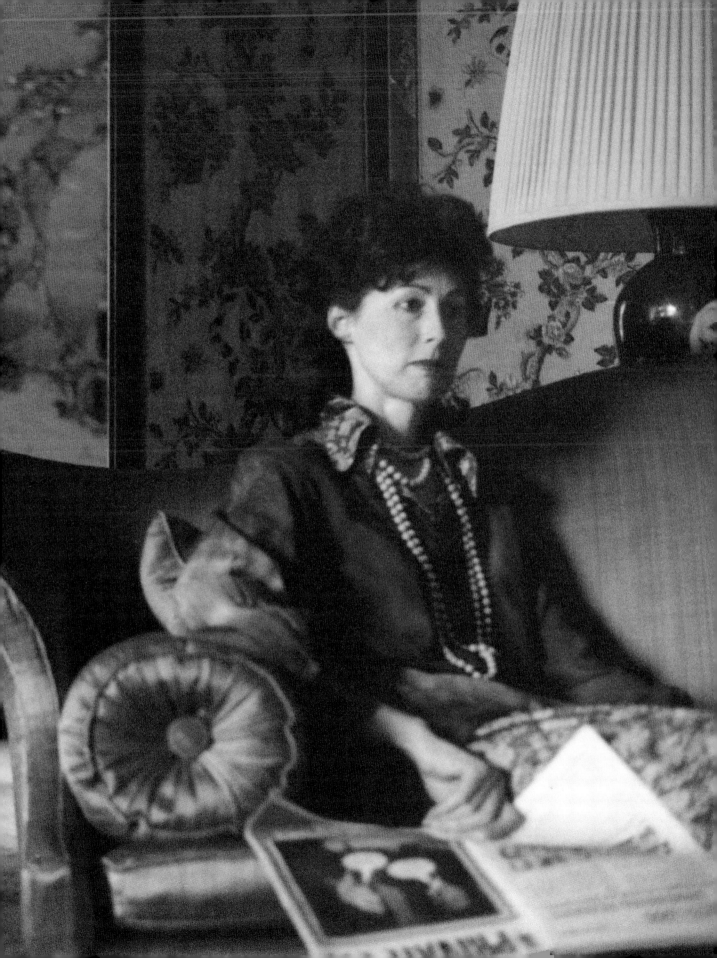

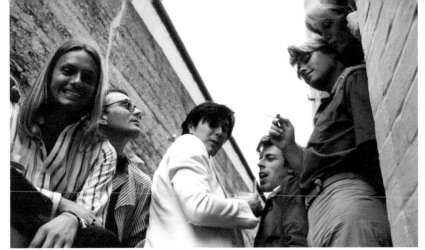

STEWART GRIMSHAW, MANOLO BLAHNIK, BRYAN FERRY, ANTONY PRICE, ERIC BOMAN, AND AMANDA LEAR, LONDON, 1974.

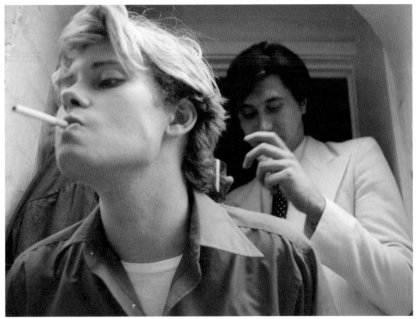

ERIC BOMAN AND BRYAN FERRY, LONDON, 1974.

At an afternoon tea party in the studio of Jose Fonseca, owner of London's top model agency, this clique of friends showed up. Stewart Grimshaw owned Provan's, the most amusing restaurant in London, where we'd laugh just reading the menu of highly inventive dishes he insisted had their roots in English cuisine; his Camembert ice cream had people running out the door. Bryan Ferry, like many rock stars, had an art school background and had been a student of Mark Lancaster's. I had met him through Antony Price, who called the sophisticated collector of English decorative art and painting a "taste tarantula."

ANTONY PRICE, BRYAN FERRY, AND ERIC BOMAN, COLVILLE TERRACE, 1974.

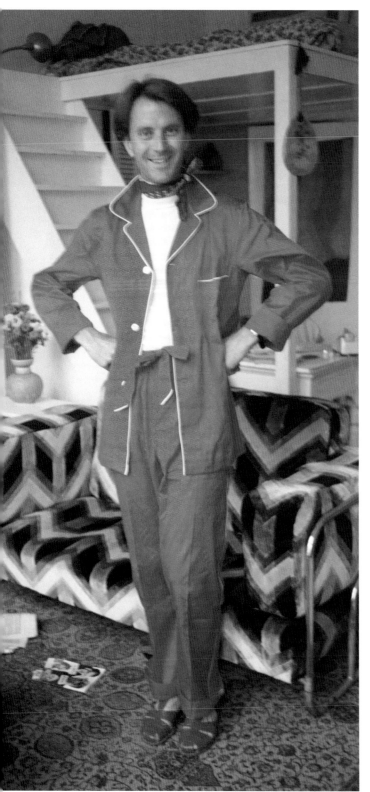

MANOLO BLAHNIK, COLVILLE TERRACE, 1973.

HELOISE VAN EGHEN, COLVILLE TERRACE, 1975.

My flat in Colville Terrace had been the drawing room of a nineteenth-century townhouse and had one large room with a loft bed and a small terrace outside three tall arched windows. Since it had to serve as studio, bedroom, living room, kitchen, and dining area, there was not much room left for decoration, but I loved it because it was the first place that was really mine. I entertained as best I could, inviting friends such as Nick Wilder, a legendary art dealer from Los Angeles who championed many famous artists early in their careers. Manolo Blahnik was always stopping in on his way up or down the stairs for a quick gossip. A model Eric Boman photographed, Heloise van Eghen, commissioned me to do a drawing of her on the couch I had covered in an art deco velvet that was all the rage.

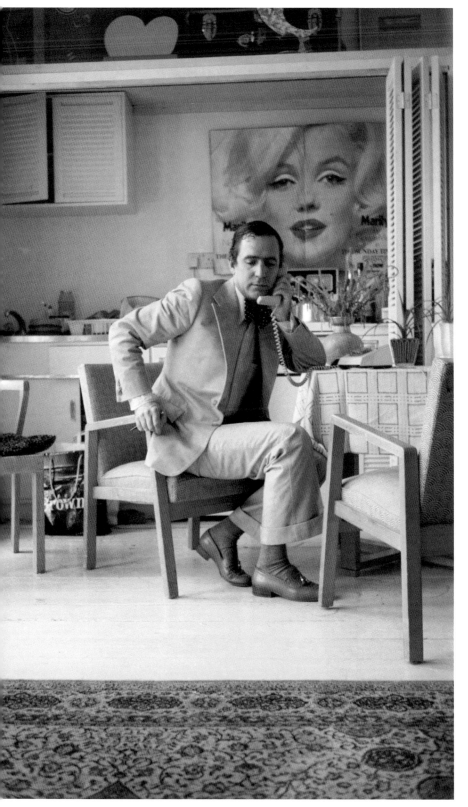

LUPINES, COLVILLE TERRACE, 1975.

NICK WILDER, COLVILLE TERRACE. 1973.

SALON, CHATEAU DE CASTILLE, 1974.

The Chateau de Castille, a house of unparalleled beauty near Nîmes, was owned by the brilliant and temperamental art collector Douglas Cooper. It was a small eighteenth-century castle built of golden stone with faux ruined Roman colonnades lining the approach. Grand yet somehow not fancy, it was summery and light and filled with the most incredible paintings by Braque, Matisse, and Cooper's friend Picasso. The collection was eventually inherited by his adopted son, the decorator Billy McCarty-Cooper.

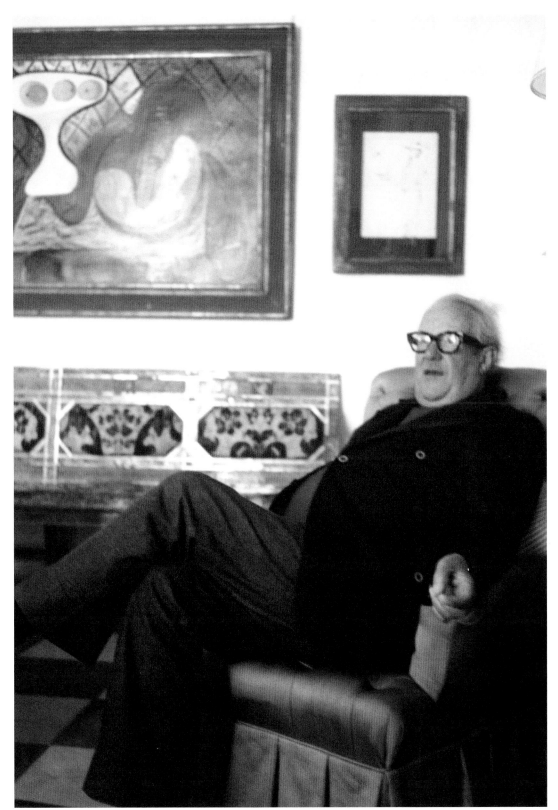

DOUGLAS COOPER, CHATEAU DE CASTILLE, 1974.

PAULETTE GODDARD, MONTE CARLO, 1974.

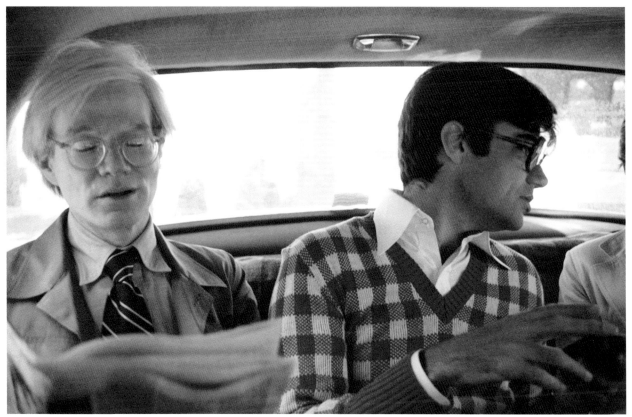

ANDY WARHOL AND REX REED, MONTE CARLO, 1974.

As a final purge of my movie fantasies I went to the Cannes Film
Festival with Jack Hazan, the director of *A Bigger Splash,* which was
entered in the festival. From there I went to Monte Carlo to see the
premiere of the underrated movie *The Driver's Seat* starring Elizabeth
Taylor. It wasn't in the festival, so her friend Princess Grace gave her a
screening and a party at Regine's. Andy Warhol was there for a show of
his portraits, and I met an idol of mine, Paulette Goddard, wearing a
T-shirt and a walnut-sized diamond ring.

UDO KIER, GLYNDEBOURNE, 1975.

For the premiere of David Hockney's sets and costumes for *A Rake's Progress* at Glyndebourne, Peter Langan, the drunken chef and owner of Odin's restaurant, gave a lavish moonlit picnic. Odin's was an artists' favorite, and at one point featured a dish named Pâté Peter Schlesinger. Langan would trade meals for paintings—I traded several.

Marguerite Littman brought her own picnic paraphernalia for wealthy aesthete Rory Cameron. Among the other guests was Udo Kier looking like Dracula, whom he later played in the Andy Warhol film.

OVERLEAF: LA PISCINE DELIGNY, PARIS, 1975. ▾

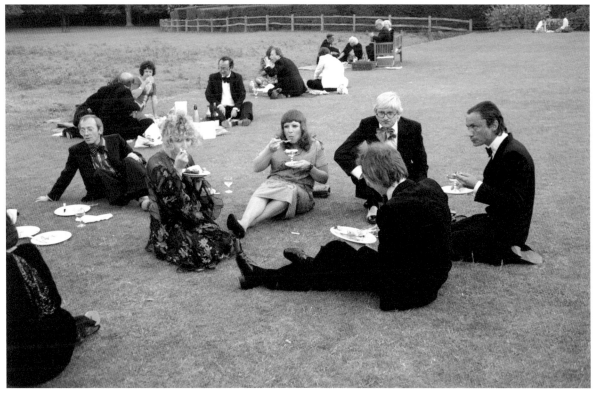

CELIA BIRTWELL, ANN UPTON, DAVID HOCKNEY, AND UDO KIER, GLYNDEBOURNE, 1975.

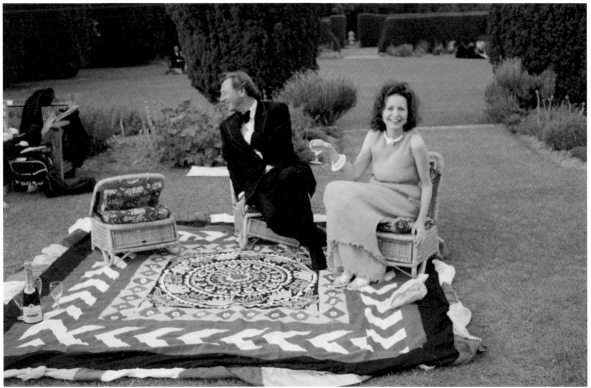

RORY CAMERON AND MARGUERITE LITTMAN, GLYNDEBOURNE, 1975.

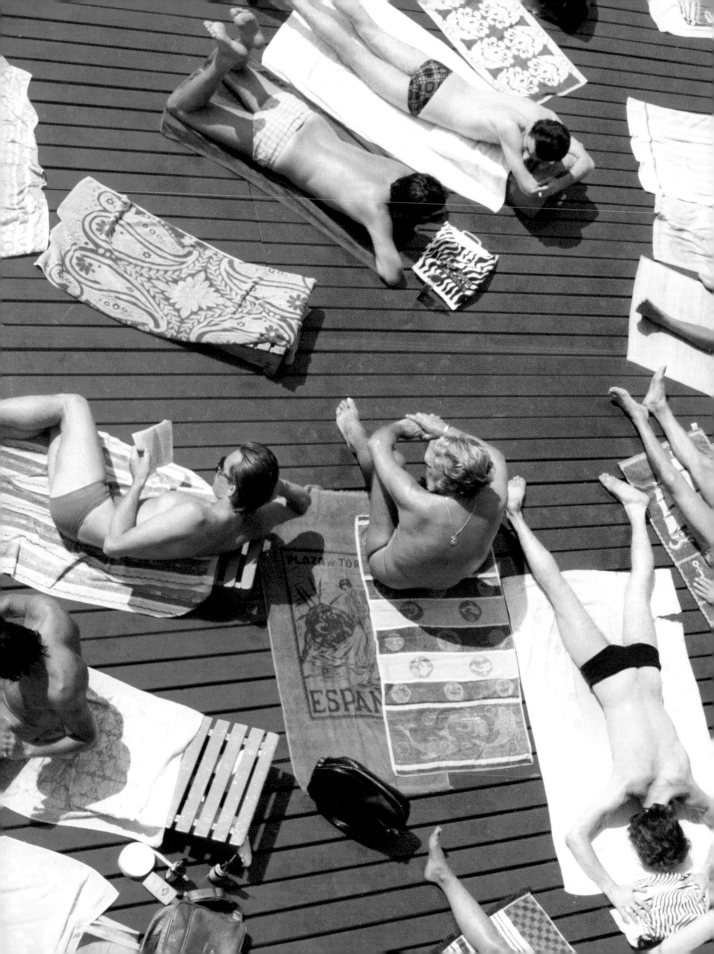

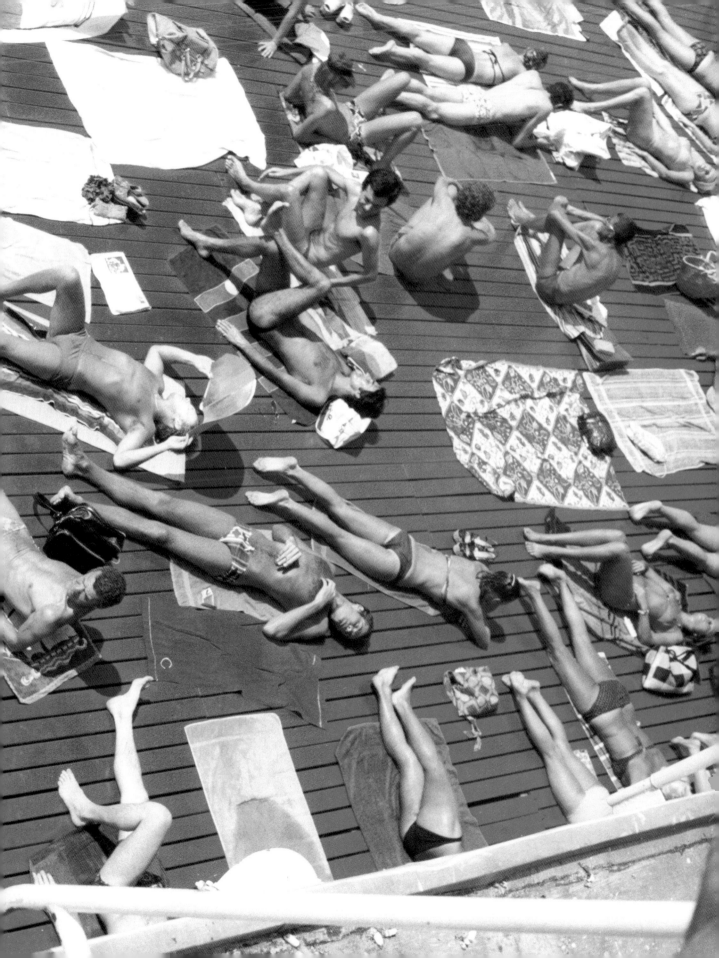

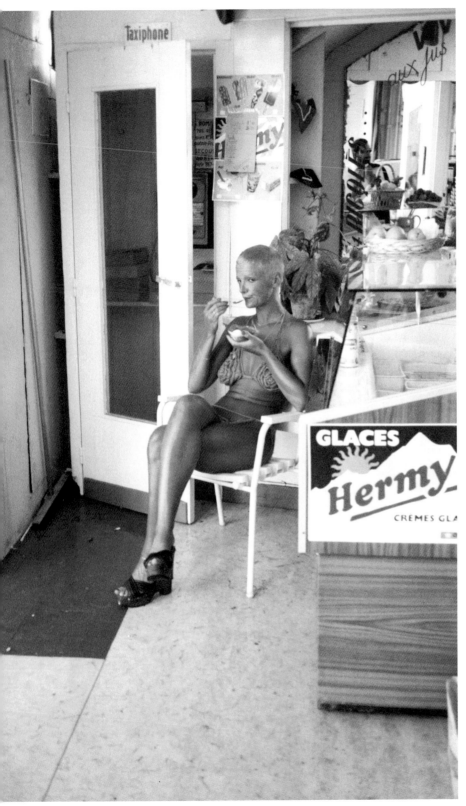

LA PISCINE DELIGNY, PARIS, 1975.

The Piscine Deligny, a nineteenth-century swimming pool that floated on the Seine and eventually sank, was a popular and cruisy people-watching and sunbathing spot where as little as legally possible was worn. An odd seasidelike presence in the middle of Paris, it provided an oasis on sizzling summer days and a challenge to the fashion-conscious to come up with new forms of exhibitionism. The woman eating ice cream came every day with different hair color and bikini to match. Jay Johnson was a model and part of the Warhol factory crowd. An infamous star and producer, Peter Berlin acted in his own pornographic films.

JAY JOHNSON, 1975.

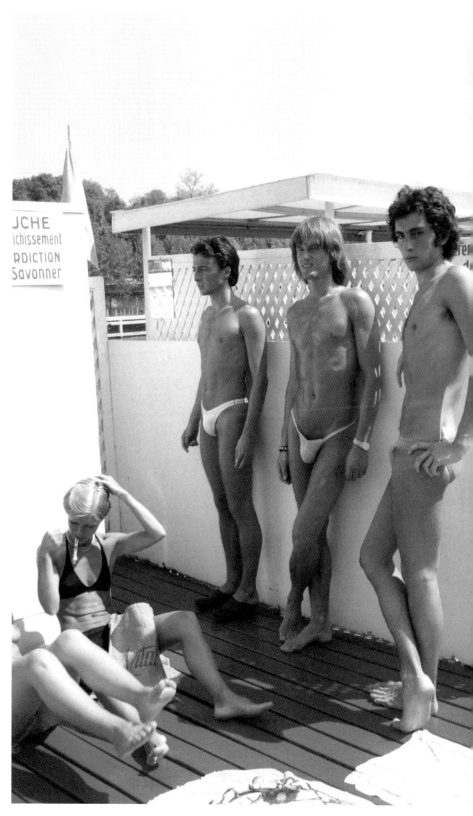

PETER BERLIN, CENTER, 1975.

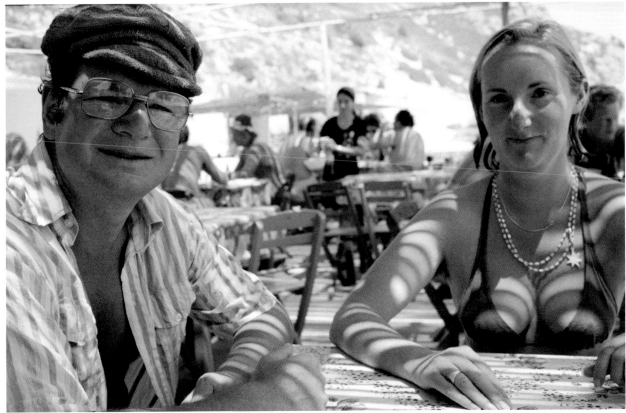

JAMES KIRKMAN AND MARY CLOW, LINDOS, GREECE, 1976.

Mary Clow, Melissa North's chipper sister, had an ancient house in Lindos on the island of Rhodes, where she generously entertained her many friends, including James Kirkman, then Lucian Freud's dealer.

Turkey was just a couple of hours away by fishing boat, but rough seas and consequent sea-green faces made it seem an eternity. Later on this trip, Eric Boman and I hitchhiked around Turkey and one night, mistaking a noisy party for a garden restaurant, we were invited to celebrate a tearful little boy's circumcision the next morning. We were plied with food and drink and had money pinned to our T-shirts as we danced for our dinner.

BODRUM, TURKEY, 1976.

DENIZILI, TURKEY, 1976.

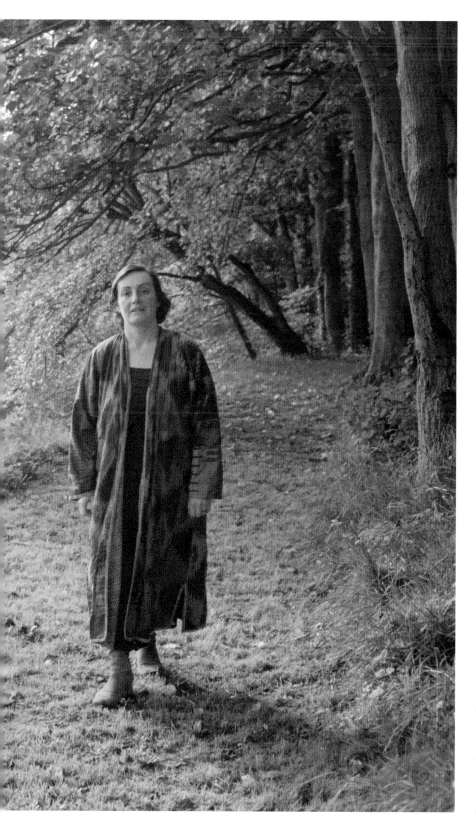

Long before the painter Howard Hodgkin became Sir Howard, he asked me to paint a portrait of his handsome wife, Julia. In preparation, I stayed at their country house several times to draw and photograph her. For some reason, I had great difficulty with the painting, and when finally finished, they didn't want it. Julia looked very gloomy, and it was rather ordinary. When they separated shortly after, I understood why.

JULIA HODGKIN, 1976.

DOUGLAS FAIRBANKS JR., LONDON, 1977.

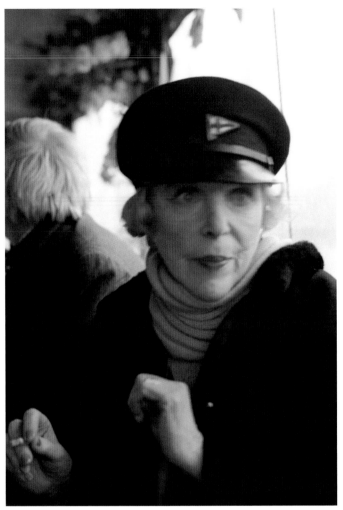

LADY DIANA COOPER, LONDON, 1977.

Queen Elizabeth II's silver jubilee was in 1977, long before her family dramas began, and there was much genuine celebration. Jack and Dru Heinz, of ketchup fame, always spent June and July in London and gave a glamorous party on a yacht to watch the fireworks from the Thames.

WATERLOO BRIDGE, LONDON, 1977.

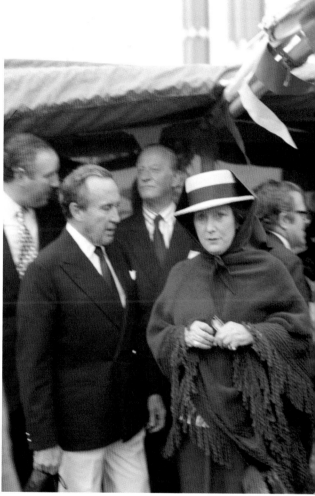

JACK AND DRU HEINZ, LONDON, 1977.

Lady Diana Cooper had a fondness for yachting caps and wore them
everywhere. For once it was completely appropriate. Soon after, there
was another party for Jack, Sheridan Dufferin, Henry Geldzahler, and
David Hockney, who all shared the same birthday.

PETER EYRE, BRIGHTON, 1977.

Marguerite Littman, Eric Boman, and I took the *The Brighton Belle* from Victoria Station to see our mutual friend Peter Eyre perform in *Stevie,* a play about the poet Stevie Smith at Brighton. Peter was a close friend of Francis Wyndham, whose mannerisms crept into the character he played.

A movie critic for David Bailey's magazine, *Ritz,* Frances Lynn was a hoot. I had started a painting of her with her two sisters, Sargent's *Wyndham Sisters* in mind, but it didn't work, so I finally painted her alone in a Diane von Furstenberg wrap dress. During breaks between posing, she did headstands in my studio.

OPPOSITE: FRANCES LYNN, LONDON, 1977. ➤

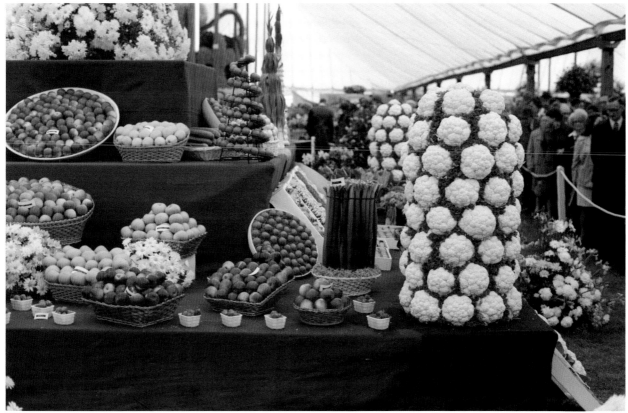

CHELSEA FLOWER SHOW, LONDON, 1977.

Everything English was what I loved and nothing was more English than the Chelsea Flower Show or the Food Halls at Harrods, where the star attraction was the artfully designed fish display, changed daily.

HARRODS, LONDON, 1976.

OVERLEAF: ERIC BOMAN, BATTERSEA, 1977.

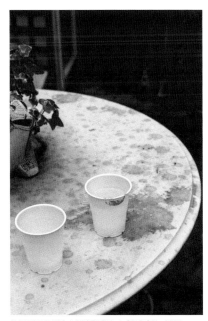

MAUREEN'S LIPSTICK, LONDON, 1977.

Lindy and Sheridan, Marquess and Marchioness of Dufferin and Ava, gave lavish parties with an extraordinary mixture of people. They had a beautiful garden behind their house near Holland Park, and at one garden tea party (actually white wine), Sheridan's mother, the Dowager Marchioness, appeared. Maureen was a great character in London society since the thirties and forties and eccentrically stylish; one fabled dress was made of playing cards.

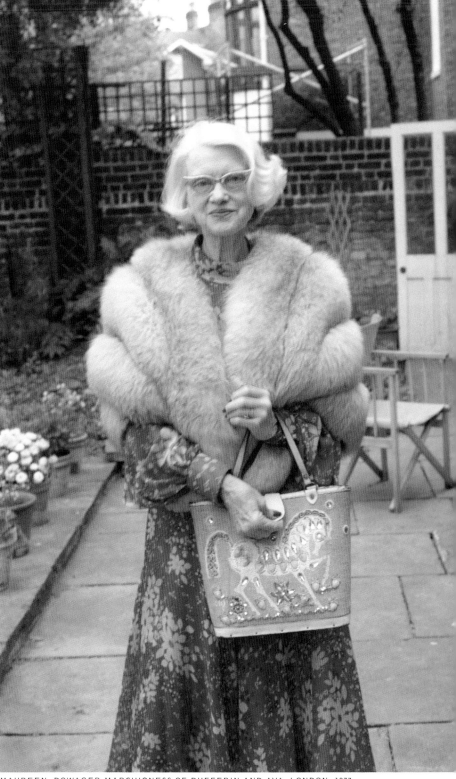

MAUREEN, DOWAGER MARCHIONESS OF DUFFERIN AND AVA, LONDON, 1977.

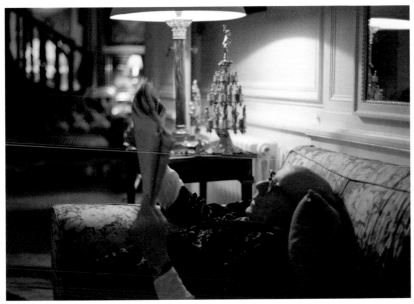

BARON PHILIPPE DE ROTHSCHILD, CHATEAU MOUTON, 1977.

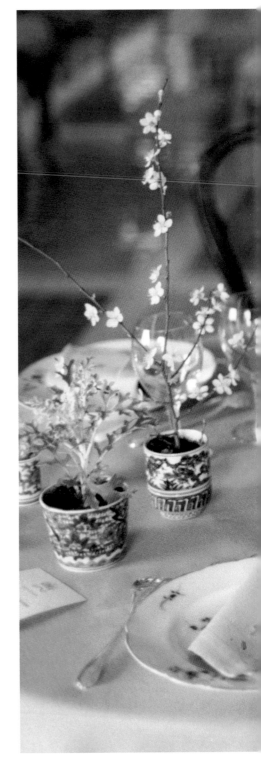

David Hockney had been commissioned to design a wine label for Chateau Mouton-Rothschild. Wanting company for the trip to Chateau Mouton, he asked Celia Birtwell, who couldn't go, and I was recruited. How could I say no? Even hard-to-please Cecil Beaton said Baron Philippe de Rothschild was the most thoughtful and stylish of hosts. He was also kind and completely unsnobbish and served the most amazing food and, of course, incomparable wines of rare vintages, served in small quantities. His late wife Pauline's traditions were carried on, such as maintaining a special garden for growing her famous table decorations, and taking every meal in a different spot, as there was no dining room.

Joan Littlewood, the innovative stage director of *Oh! What a Lovely War,* was a neighbor and frequent guest.

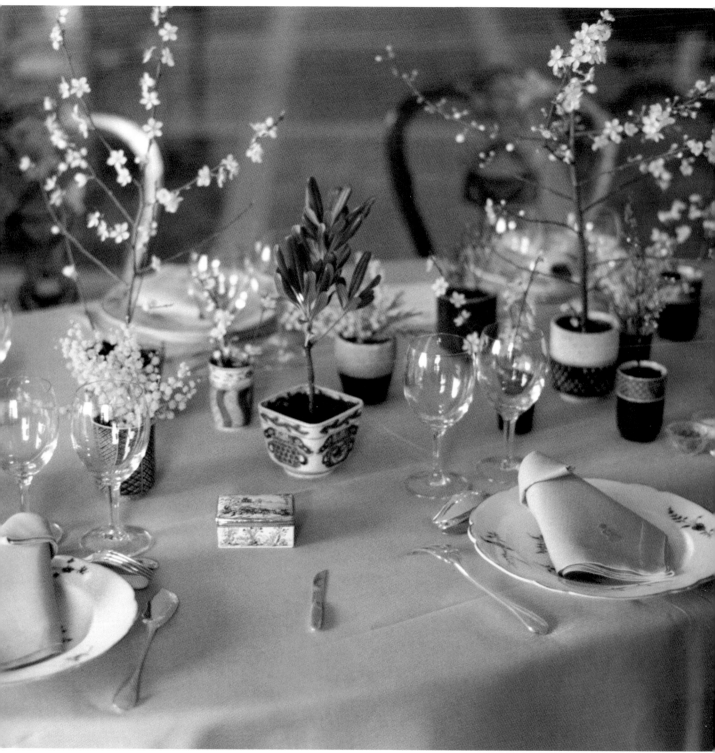

LUNCH TABLE, CHATEAU MOUTON, 1977.

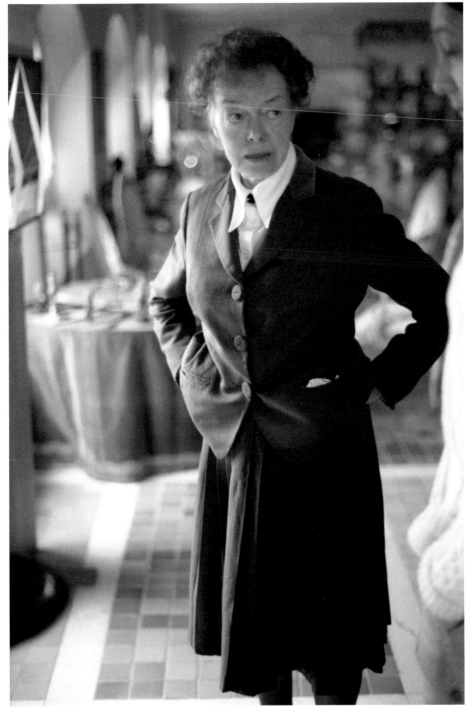

JOAN LITTLEWOOD, CHATEAU MOUTON, 1977.

BEDROOM, CHATEAU MOUTON, 1977.

SALON, CHATEAU MOUTON, 1977.

STEWART GRIMSHAW, WEST SUSSEX, 1977.

Of all the country houses I spent weekends at, Stewart Grimshaw's eighteenth-century house in West Sussex was where I went the most. Stewart loved chocolate, and violet creams were always on hand. One Easter he was the thrilled recipient of a giant chocolate egg.

ERIC BOMAN, SAINT-TROPEZ, 1978.

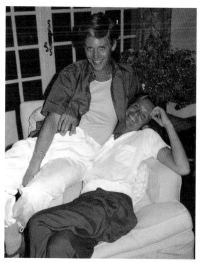

ERIC BOMAN AND STEWART GRIMSHAW,
SAINT-TROPEZ, 1976.

Stewart Grimshaw's house in Saint-Tropez overlooked the gulf and
Sainte-Maxime, where according to one houseguest "the slightly poor
people lived." His cook Dorine served the most delicious food. Regulars
included Tommy Nutter of Savile Row and Amanda Lear, who
pretended it was her house in press pictures.

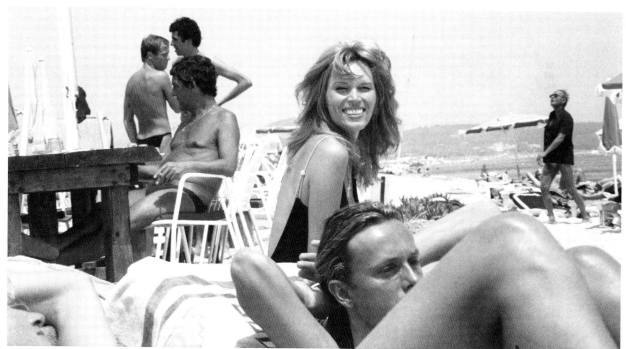

AMANDA LEAR AND STEWART GRIMSHAW, SAINT-TROPEZ, 1978.

PALOMA PICASSO, PARIS, 1978.

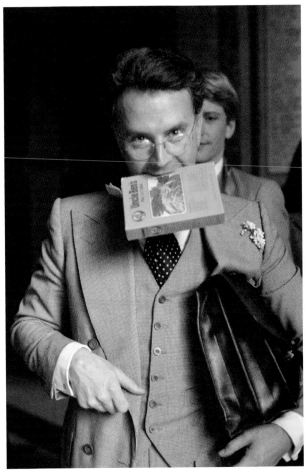

MANOLO BLAHNIK, PARIS, 1978.

Paloma Picasso's wedding to Rafael Lopez-Sanchez lasted several days. The ceremony was presided over by a clerk with eyebrows painted on the middle of his forehead, which Paloma adored. Her admirer Yves Saint Laurent designed her white suit.

Manolo Blahnik threw Uncle Ben's rice, and Anna Piaggi, the Italian *Vogue* editor and legendary costume collector, appeared as a character from Proust reincarnated at the *Mairie du VIIe*.

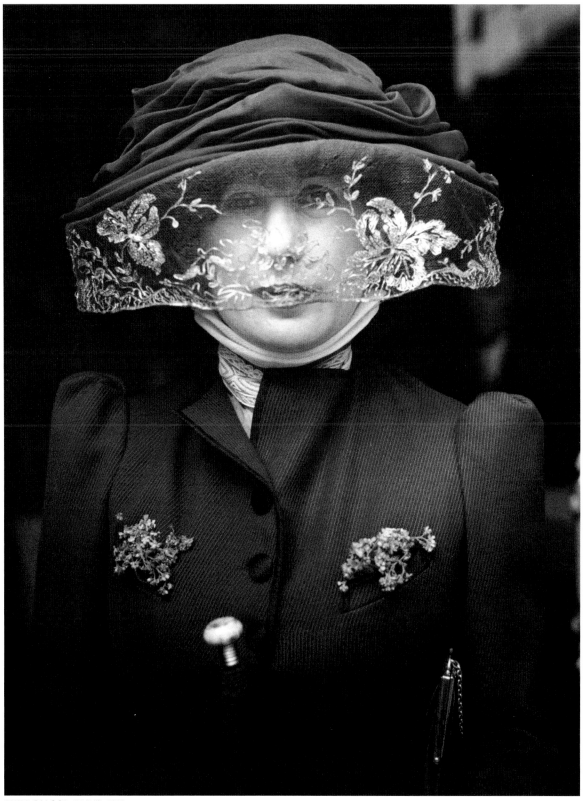

ANNA PIAGGI, PARIS, 1978.

TINA CHOW, PARIS, 1978.

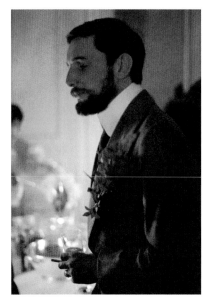

JACQUES DE BASCHER DE
BEAUMARCHAIS, PARIS, 1978.

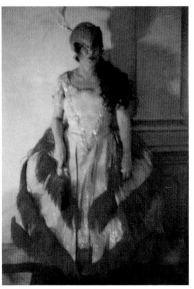

ANNA PIAGGI, PARIS, 1978.

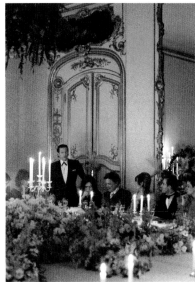

SALON, PARIS, 1978.

The celebration continued with a candlelit dinner at Karl Lagerfeld's eighteenth-century *hôtel particulier,* where a table filled an entire salon, barely allowing the waiters to squeeze by along the walls, and Anna Piaggi's plumed helmet caught dramatically on fire.

After the dinner, Paloma Picasso, in Lagerfeld, and Tina Chow, in vintage Mainbocher, refreshed their makeup in preparation for the dancing that followed.

OPPOSITE: PALOMA PICASSO AND TINA CHOW, PARIS, 1978. ➤

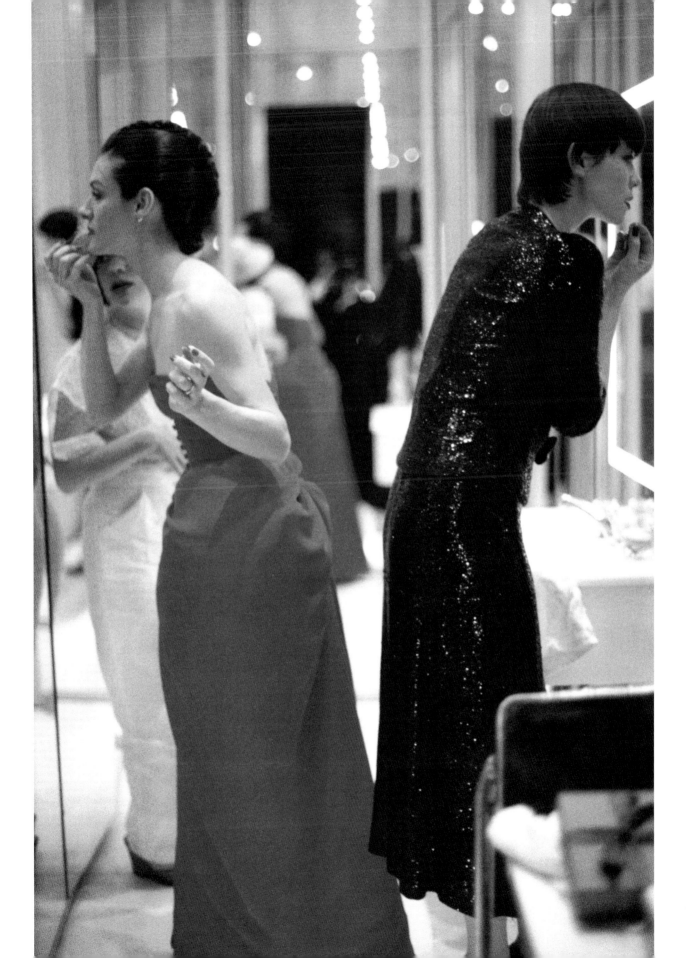

THE EARL OF DROGHEDA, 1978.

JESSICA DOUGLAS HOME AND HER
CHILDREN, 1978.

Peter Eyre suggested to his great friend Diana Phipps that she should invite Eric Boman and me to the coming-out ball of her daughter, where everyone had to dress as a character from an opera. Her American in-laws sent over from Old Westbury, Long Island, their flowered tent seating three hundred. Diana went as the Marschallin from *Der Rosenkavalier*. I went as Teresias from *Les Mamelles de Teresias*, and Gore Vidal thought I was Myra Breckinridge. Decorator Nicky Haslam caused a ruckus as a Nazi from his own fantasy opera, and Lady Diana Cooper wore the original costume from her 1931 stage appearance in *The Miracle*.

LADY DIANA COOPER, 1978.

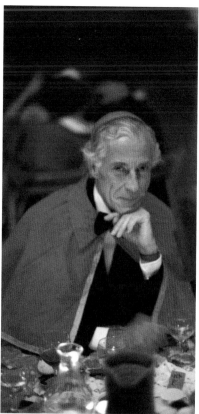

JOHNNY GALLIER, 1978.

PAMELA HARLECH, 1978.

DIANA PHIPPS, 1978.

GORE VIDAL AND NICKY HASLAM, 1978.

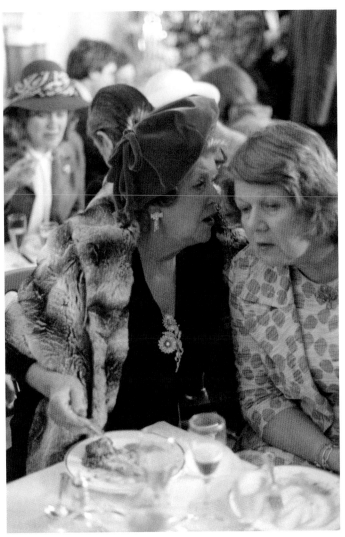

MIN HOGG, 1978.

LADY BEAUCHAMP AND LADY COOPER, 1978.

Victoria Marten had met Eric Boman on Patmos, and they became close friends. She was lots of fun and deeply involved with teaching children. Soon after the stay in Greece, she went on a motorcycle trip to Scotland with a fellow schoolteacher, wearing Eric's motorcycle jacket and a twinkle in her eye.

Her mother, Maryanna, an old friend of Cecil Beaton's, had inherited a large eighteenth-century estate in Wiltshire and torn down

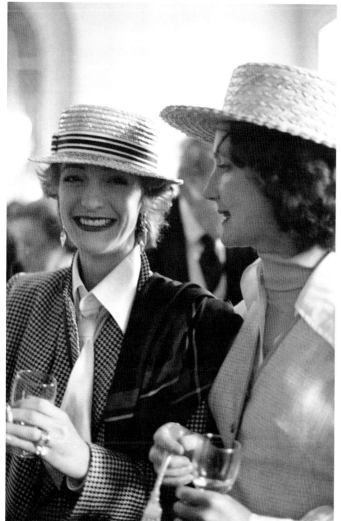

LOULOU DE LA FALAISE AND LINDY DUFFERIN, 1978.

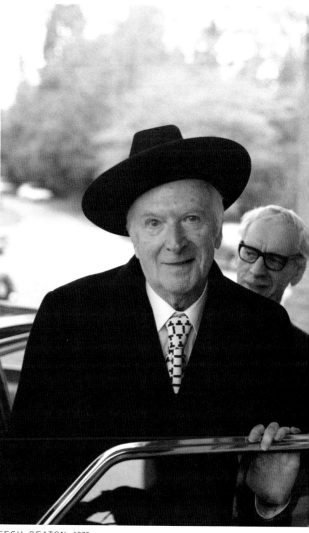

CECIL BEATON, 1978.

the later buildings and restored the main house. Critchel became the perfect setting when Vicky married the man on the motorcycle. Min Hogg, Eric, and I took the train to Salisbury in all our finery. By this time, Eric had become a photographer, and he took the wedding portrait. Cecil, kinder after a stroke, gave him a rare compliment.

IN FLIGHT, 1978.

Gradually, during all these years, London had undergone great changes. Terrorist bombs had replaced the fireworks, there were endless electricity blackouts, and the deepening depression eventually brought Margaret Thatcher to power. In this new climate, it became increasingly difficult to imagine my future in England.

New York beckoned. Now the center of art and fashion, many of our friends had already moved there. Eric Boman went to New York in the spring of 1978 to explore the possibilities.

The idea of leaving England was troubling for me. After having been so determined to leave California, the thought of returning to the United States somehow felt like I was giving up my romantic idea of the expatriate American. But nothing stays the same, and by that summer, I happily joined Eric in New York.

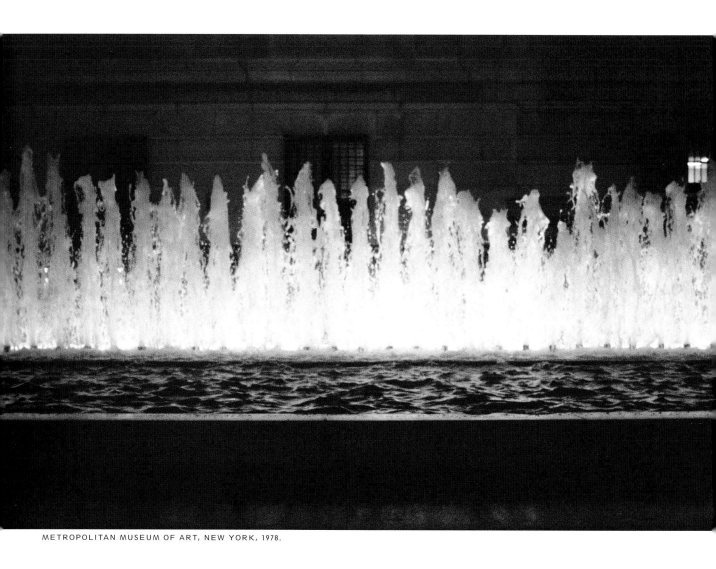

METROPOLITAN MUSEUM OF ART, NEW YORK, 1978.

index

Numbers in *italics* refer to illustrations.

acknowledgments

I had long hoped to one day make a book from my photo albums, but it took my friend Gail Monaghan to turn enthusiasm into action. She introduced me to Mark Magowan, who believed in the idea and knew how to give it form. I thank them both for their encouragement.

Many thanks to everyone who appears on these pages, especially to Manolo Blahnik, Bryan Ferry, and David Hockney for their generous contributions; to Min Hogg and Peter Eyre, whose excellent memories helped answer my interminable questions; and to George Lawson and Wayne Sleep. I also want to thank my designer, Laura Lindgren; my editor, Constance Herndon; and Constance Kaine of Thames & Hudson for her invaluable suggestions.

Most of all I am grateful to Eric Boman, whose cheerful support throughout the making of this book made it all the more fun.

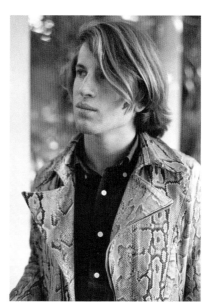

PETER SCHLESINGER, LOS ANGELES, 1969.

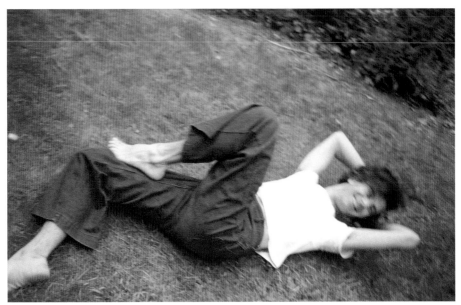

MANOLO BLAHNIK, PARIS, 1972.